A–Z of Lighting Terms

DEDICATION

Behind every man there is a good woman! (or so I'm told).

I am very lucky that my wife, Carole, has always taken an interest in my career and has been involved with much of my work for over 30 years, to the point where I have to watch what I say because she is now capable of catching me out! To be totally honest, I admit that without her English translations of my material I would never produce a book.

I am very lucky in having a second woman in my life – Margaret Riley, my editor at Focal Press. She has coped with my artistic tantrums for a number of years with tact and diplomacy, and is not only my editor but a close friend to Carole and me.

Without these two ladies, I doubt if I would ever get around to writing anything as I am essentially a procrastinator – so to both of them I say a large thank you for the encouragement – generally called nagging!!

A–Z of Lighting Terms

Brian Fitt

Focal Press

OXFORD AUCKLAND BOSTON JOHANNESBURG MELBOURNE NEW DELHI

Focal Press
An imprint of Butterworth-Heinemann
Linacre House, Jordan Hill, Oxford OX2 8DP
225 Wildwood Avenue, Woburn, MA 01801-2041
A division of Reed Educational and Professional Publishing Ltd

 A member of the Reed Elsevier plc group

First published 1999

British Library Cataloguing in Publication Data
A catalogue record for this book is available from the British Library

Library of Congress Cataloguing in Publication Data
A catalogue record for this book is available from the Library of Congress

ISBN 0 240 51530 7

Typeset by Avocet Typeset, Brill, Aylesbury, Bucks
Printed and bound in Great Britain by Biddles Ltd, Guildford and
King's Lynn

FOR EVERY TITLE THAT WE PUBLISH, BUTTERWORTH-HEINEMANN
WILL PAY FOR BTCV TO PLANT AND CARE FOR A TREE.

CONTENTS

INTRODUCTION

When I first started in lighting the only way to learn the terms and procedures was to listen carefully to Lighting Directors and electricians with whom I worked. One of those Lighting Directors was Gerry Millerson who showed me a draft book he had written which he felt might be useful as a learning tool. This was in the early 1970s and, after several reprints and three editions, *Lighting for Television and Film* certainly became one of the world's best-sellers on lighting. His book explains the artistic side of lighting with some reference to the technical requirements.

When Joe Thornley and I wrote *Lighting Technology* it was an attempt to provide a complementary 'technical' book to *Lighting for Television and Film* and, from all reports, seems to have succeeded in its aims. Harry Box, a film gaffer in the USA, produced *The Set Lighting Technician's Handbook*, giving a valuable insight into the Hollywood film industry and, recently, I had the honour of editing a European version which is now called *The Gaffers' Handbook*. I found it fascinating to compare American and European terms and practices and have tried, in this new book, to give a transatlantic flavour, particularly as there is so much common ground.

For the student commencing a career in lighting, it would be an expensive exercise to acquire the books mentioned above and I felt that a 'pocket guide' would be a useful introduction to the industry, and certainly less daunting to read. I have tried to cover as many terms as possible but no doubt the reader will immediately think of some I've missed. For that I apologise (and if you would be kind enough to let me know, I will include them next time!). The main principles of lighting concern the Square Law, Cosine Law, luminaire optics and

accessories, together with the means of rigging, and detailed explanations are given on these subjects.

It is said that there is a book in most people and as I have already been involved with four I feel I may be pushing my luck! I hope this 'mini encyclopaedia' of lighting will prove useful and informative – not only to students but to anyone interested in the art of lighting.

A

ASA
1) American Standards Association (now ANSI).
2) The exposure index (EI) rating of a film emulsion, also referred to as ISO.

Typical film emulsion speeds are 32, 64, 125, 200, 400, 800 and 1000. The larger the number the faster the film and, when the numbers double, this indicates an increase of one stop in speed.

AWG (American Wire Gauge)
These sizes are based on the diameter of the wire expressed in mils (1/1000″) or its cross sectional area (CSA), expressed as circular mils (Cmils).
See Cmils.
Typical cable sizes are given below, with the nearest practical metric equivalent:

AWG	CSA in Cmils	CSA in sq. mm
4/0	212 000	120
3/0	168 000	95
2/0	133 000	70
1/0	106 000	50
2 AWG	66 400	35
4 AWG	41 700	25
6 AWG	26 200	16
8 AWG	16 500	10

Absorption filter
A filter which transmits selected wavelengths. The absorbed energy is converted to heat which raises the temperature of the filter.

Accent light
See Key light, Kicker and Backlight.

Acceptance angle
The field of view covered by a lens or a light meter photosensitive cell.

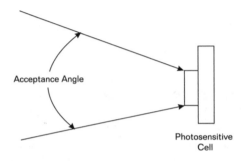

Figure 1 Acceptance angle

Ace (USA)
1 kW Fresnel luminaire.

Acting area
That portion of a stage or studio used by the actors during rehearsals and performances.

Adapter
A device used to convert from one type of electrical connector to another.

Additive colour mixing
The superimposition of light beams, usually consisting of the primary colours, whereby the resultant light is the addition of the various wavelengths concerned. If three primary colour filters are used together with a source of white light *(used to dilute the colour)* it is possible to create most of the spectral colours.

	Red + Blue	=	Magenta
	Red + Green	=	Yellow
	Blue + Green	=	Cyan
and	Red + Blue + Green	=	White

In practice it is difficult to use the absolute primaries as the filters required have very low transmissions and thus reduce the light output by a considerable amount, e.g. a deep blue will only have about 0.6 per cent transmission.
See also Subtractive colour mixing.

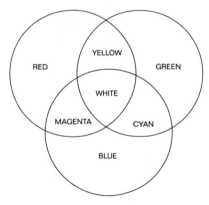

Figure 2 Additive colour mixing

Alligator clip
Metallic spring loaded clamp, similar to a clothes peg, with pointed teeth on the jaws of the clamp. Used for making temporary electrical connections.

Alternating current (a.c.)
Electric current whose flow alternates in direction. The time of flow in one direction is a half period and the length of all half periods is the same. The normal waveform of a.c. is sinusoidal *(see Figure 3)*.

(a) Single phase resistive current

Note: current *lags* applied voltage by $1/4$ cycle or 90°

(b) Single phase inductive circuit

Note: current *leads* applied voltage by $1/4$ cycle or 90°

(c) Single phase capacitive circuit

Figure 3 a.c. current

Ambient light
General background light which may be natural or provided by working lights, houselights, etc. (also known as Available light).

American National Standards Institute (ANSI)
An independent association that establishes standards to promote consistency and interchangeability among manufacturers. This organization was formerly known as the United States of America Standards Institute (USASI or ASI) and previously as the American Standards Association (ASA).Three-letter ANSI codes are used to identify lamps (e.g. EGT is a 1 kW lamp).

Ammeter

A meter for measuring current (*amperage*). Two types of meter exist for measuring current

1) Analogue – using a pointing device on selected scale.
2) Digital – either using selected scale ranges or auto selection.

One of the drawbacks of ammeters is that they have to be in series with the circuit, which is fine if the circuit is low current, but difficult with values above 10 A. Therefore a current transformer has to be used to keep the output to a reasonable value to match the ammeter input. A 100:1 transformer will reduce 1000 A in the main conductor down to 10 A at the input of the ammeter.

Permanent current transformers require that the cables are passed through the centre of a copper coil (doughnut shaped). Another method, which is the most popular when measuring the current in distribution cables, is the current clamp, where it is possible to effectively 'open the doughnut' to surround the cable.

Ampacity (USA)

American term for the current carrying capacity of cables.

Ampere

Measurement of current. One volt applied to a resistance of one ohm produces a current of one ampere.

Ampere-hour

A measure of a battery capacity equal to the number of amperes times the number of hours of charge that a battery can deliver. For example a battery providing 6 A for one hour is rated at 6 Ah. The same battery providing 10 A will only last 40 minutes (0.66 of an hour). Typical battery life (6 Ah approximately) for luminaires using 250 W lamps is around 45 minutes with a battery in good condition. Older batteries may only provide 20–30 minutes of use.

Angle of incidence
The angle subtended by the rays of a light source to the plane of the subject being illuminated.

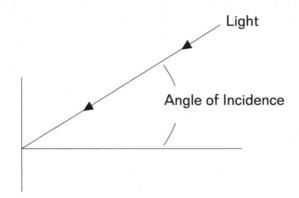

Figure 4 Angle of incidence

Anode
A positive electrode in a light source using direct current. One of the carbons in an arc light or one of the electrodes in a xenon lamp. **Note:** With alternating current sources such as the H.M.I., the electrodes will alternate between positive and negative according to the direction of current flow.

Aperture
The adjustable opening in an iris to control the intensity of light. The size of the aperture is denoted by its 'f-number'. *See also F-number, T-stop and Iris.*

Apple box
A reinforced plywood box used on the set for many purposes, including to raise an actor who is too short or to raise furniture. Apple boxes come in four sizes: full (20×12×8), half (20×12×4), quarter (20×12×2) and pancake (20×12×1) – measured in inches.

Arc

The discharge created between two electrodes usually with a fairly low voltage and high current. Has to be controlled by a ballast arrangement.

Once an arc has been struck, unless special measures are taken, the current will keep increasing due to the low resistance (impedance) of the circuit. If a resistance is connected in series with the arc, it will reduce the volts applied to the arc in proportion to its resistance and the current flowing. Carbon arcs require approximately 60 V d.c. across the carbons, therefore on a 120 V supply 60 V needs to be dropped across the ballast resistance. If using a 150 A arc, this equates to $R = V/I$, $R = 60/150$ which equals 0.4 ohms and, incidentally, the dissipation in the ballast resistance is 9 kW.

See also Carbon arc.

Arc light

Old term for a luminaire using a carbon arc discharge as the source of illumination. Also describes modern discharge sources such as M.S.R., H.M.I., C.S.I., etc.

Articulated arm

An adjustable device consisting of short pieces of tubular metal joined together by ball and socket joints. Used to hold gobos or flags, normally attached to a stand or rigged on other grip equipment or scenery.

Artificial light

Light coming from any source other than the sun, sky or moon.

Aspect ratio

The ratio of the width to the height of any imaging system. The standard aspect ratios are 4:3 (standard television), 16:9 (high-definition television), 1.66:1 (European film standard),

1.85:1 (American wide-screen standard) and 2.36:1 (Anamorphic 35 mm).

Atmosphere
The mood of a scene created by the lighting, set design, costumes and make up. Additionally, influenced by sound effects, music, etc.

B

Baby
1 kW Fresnel luminaire manufactured by the Mole Richardson Co.

Baby plate
A metal plate complete with 5/8″ female spigot holder which can be fastened to wooden surfaces, such as apple boxes, set walls, etc. using nails or wood screws. These are then used to mount small luminaires in positions where space is at a premium.

Baby stand
A stand with a 5/8″ spigot used for small luminaires.

Baby stud
A 5/8″ spigot that mates with a 5/8″ female spigot holder.

Backdrop *(Backing)*
A scenic painting or enlarged photograph transparency used to limit the view of the audience or a camera through openings such as doorways or windows.

Backing lighting
The illumination provided for scenery and backdrops, usually from softlights or floods such as a Skypan.

Backlight
Luminaire(s) used to light the subject from the rear to help separation from backings and to increase the three-dimensional effect.

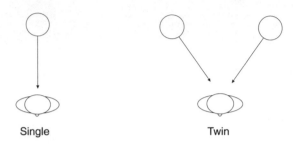

<div align="center">

Single Twin

</div>

Figure 5 Backlight

Bail *(Yoke)*

U-shaped part of a luminaire fitted with a spigot (5/8″ or 1 1/8″) which allows the luminaire to be attached to a C clamp or stand. The yoke acts as the pivotal point of the luminaire for pan and tilt.

Bailing wire (USA)

A thin flexible wire used as safety wire for barndoors, snoots and other luminaire attachments.

Balance

1) The relationship of light and shade in a scene to establish the mood and atmosphere, e.g. high key or low key.
2) The maintenance of lighting levels between scenes to prevent exposure differences.

See High key, Low key.

Ballast

The electrical device, required for all discharge lamps, that limits current through the lamp. DC devices, such as the carbon arc, use a resistor *(see Figure 61)*. When using a.c. there are three ways in which current can be controlled:

1) A resistor.
2) A capacitor.
3) An inductor.

The disadvantage of using a resistor is a high power loss and consequently heat. The capacitor has the lowest loss but the waveform produced can damage the electrodes. These disadvantages have led to the inductor being the most commonly used type of ballast for discharge sources. Unfortunately, the power factor of the system will be very low and typical values are between 0.5 and 0.7. The supply authorities require that the power factor is as near unity as possible. This is usually accomplished by placing a capacitor across the ballast.

Choke ballasts are very heavy and some require a boost transformer to maintain lamp voltages. Electronic ballasts overcome the weight problems by using switching regulators to control the output current, thus avoiding the need for a choke.

Discharge lamps, in practice, vary in their operating performance due to the manufacturing methods employed. Even from the same manufacturer there are slight variations in the arc voltage. If low, this means that the lamp output wattage will be lower than the stated output. Others may have higher voltage characteristics and this means that the power will be above the stated value. In the first case this will mean that the light out is below normal but in the second, can cause overheating in the arc and short lamp life. The lamp voltage also varies with age. An electronic ballast system can sense the volts and current and automatically adjust one to the other to give 'power control' so that the wattage output of the lamp is kept consistent with the manufacturers' stated values. Another advantage of electronic ballasts is that by using square wave outputs with rapid transition between positive and negative half cycles, flicker problems can be overcome. The frequencies of the square waves used with flicker-free ballasts are between 40 Hz and 400 Hz.

Another advantage of the electronic ballast is that it is possible, with the correct selection of the discharge lamp, to

obtain a degree of dimming. However, dimming can only be performed over a comparatively small range, typically 50 per cent of the light output before the arc becomes unstable. One major problem that can exist during dimming is a colour shift so it is wise therefore to do tests before relying on dimming a discharge lamp.

Banded cable
Several single-core cables taped together at regular intervals forming, in effect, one large multi-core cable.

Bank
Used to describe groups of lights, such as several scoops or softlights. Also luminaires containing several PAR lamps.

Barndoors
Movable flaps usually attached to a Fresnel or PC luminaire to shape the light beam. Generally consists of two small flaps and two large. Some barndoors are also equipped with subsidiary pieces on the individual doors in an attempt to improve their performance. Barndoor effectiveness depends upon the optics of the light source, the reflector, the length and colour of barndoors and the distance from the light source. Barndoors are always coated in matt black paint to prevent secondary reflections from the internal portion of the barndoor leaves. When the light source is reasonably well focused, such as a Fresnel, the barndoor performance is fairly good. In the case of open faced luminaires, such as the Redhead, mainly due to the reflector there are secondary shadow effects produced by the barndoor leaves which give an unsatisfactory result. Both Fresnels and open faced luminaires vary in barndoor efficiency depending on whether they are in 'spot' or 'flood'. As the distance from the front edge of the barndoor to the light source becomes greater the

efficiency of shadow detail is improved and thus the doors are more effective. Obviously, in practice, there is a finite limit to the size of doors.

Barrel (colloq. Bar)
A metal tube, generally 48 mm diameter, for suspending luminaires or scenery. Usually manufactured from steel or aluminium.

Base
1) The basket on the underside of a luminaire.
2) The part of a lamp used for the electrical connection to the power supply is called the base. *(It is also known as the 'cap'.)*
3) The lamp socket is also sometimes called the base.

Base light
The basic intensity of 'soft' lighting required to satisfy the minimum viewing or technical requirements.

Basher
A small luminaire of around 500 W used as a kicker.

Batten
1) Horizontal pipe on which luminaires or scenery can be hung.
2) Floodlight unit with different compartments for coloured filters used in theatrical lighting.
3) (USA) Refers to 3″ × 1″ timber.

Battery
See Ni-cad batteries.

Battery belt
A battery pack mounted on a belt that can be worn around the waist during location shooting.

Battery pack

Used on location where an electrical supply from the mains is not available.

The most popular batteries for size-to-weight ratio are nickel-cadmium. Typical luminaires used with battery packs have open-faced reflectors, containing a tungsten halogen or discharge lamp. The largest tungsten halogen lamp is 250 W at 30 V and the range of daylight discharge lamps include 125 W, 200 W, 275 W and 400 W. The battery unit will also be complete with a high frequency converter for the discharge lamp.

Bazooka

An adjustable extension tube with a 1 1/8″ spigot for mounting luminaires on catwalks. It is similar to a small stand minus its legs.

Bead board

Styrofoam used to make soft bounce light.

Beam

The unidirectional flow of total light output from a source, usually a luminaire.

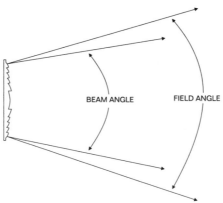

Figure 6 Beam and field angles

Beam angle

Those points on the light output curve which are 50 per cent of maximum output. The included angle between these two points is the beam angle.

Beam light

This luminaire employs a parabolic reflector with the lamp placed at the centre of focus. With a true radius reflector placed in front of the light source, some of the light is reflected back through the filament to the parabolic reflector. In an ideal arrangement, the optical system would produce a parallel beam of light, the same diameter as that of the reflector. In practice the size of the source has the effect of slightly spreading the beam and typical beam angles are 4° to 8°. The beam light was originally used in large opera houses and theatres, because of its high efficiency and narrow beam when the luminaires were positioned a long distance from the acting area. The most efficient beam lights use low voltage lamps to provide a compact source which has the drawback of requiring a transformer in the mains supply line. Typical voltages are 12, 24 and 48.

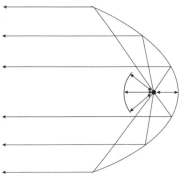

Figure 7 Beam light

Beaver board

A nail-on plate mounted to an apple box.

Best boy (girl)
The assistant chief lighting technician or second electrician, and is the gaffer's chief assistant.

Big eye (USA)
A 10 kW incandescent luminaire with an extra large lens (Mole Richardson).

Black light
Radiation in the near-ultraviolet (320–400 nm) used to make paints, dyes and materials fluoresce. As UV radiation is invisible to the eye, it is possible to use it for special effects where apparently, in darkness, materials glow as though they were normally illuminated. As with any other UV radiation, it is important that it does not cause hazard to human beings.

Black wrap
Thick aluminium foil painted with matt black to control spill light from luminaires. This should be used with caution if applied very close to a lens as it may cause localized overheating and crack the lens.

Blackbody
A body which completely absorbs any heat or light radiation falling upon it, thus becoming, in theory, invisible. In practice most black objects reflect light, e.g. black telephone. The nearest natural material to a perfect blackbody is carbon deposits, e.g. soot.

Blackbody curve
The curve which describes the change in colour of a blackbody when it is heated. Commences at black and passes through deep reds and orange (approximately 2000 K) to white and blue/white (approximately 20 000 K).

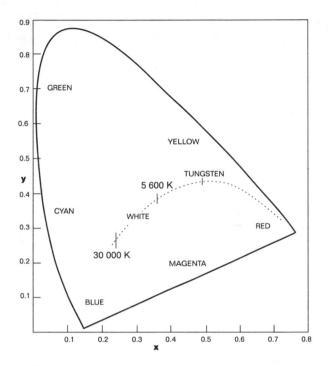

Figure 8 Blackbody curve

Blackbody radiation

Radiation that comes from an ideal blackbody. The distribution of energy is dependent only on the temperature of the blackbody and is governed by Planck's radiation law. *See Colour temperature.*

Blackout

To switch all channels to 'off' on a lighting console. Also refers to switching off all illumination, except the exit lights.

Blackout switch

A master on/off switch used for controlling the overall production lighting for either stage or studios.

Blacks
Black drapes used to exclude extraneous lighting, particularly when shooting night scenes in daylight conditions.

Blade
A narrow flag used to control small hot spots from a light source and may either be a solid object or pieces of translucent material.

Blind
Refers to changes made on a lighting console which do not affect the 'live' console output *(usually called Blind Plotting)*.

Blonde
A 2 kW open faced luminaire, originally manufactured by the Ianiro Lighting Company in Italy, and now used as the general term for any 2 kW open faced luminaire.

Board
A name for a lighting control desk *(derived from 'switchboard')*.

Boom
An extendable arm fixed to a stand to mount small lighting fixtures which may be moved to adjust the lighting on the subject.

Boomerang
A device attached to the front of the luminaire holding sets of filters. They are generally provided at the front of follow spots for colour changing.

Bounce lighting
Directing light onto a large diffuse surface, such as white card or plastic, to produce a soft reflected light. It is important that the board is neutral in colour so that no unwanted colour cast is produced on the subject.

Bracket

The small supports on the front of a luminaire which hold the barndoors, colour frame, scrims and other accessories.

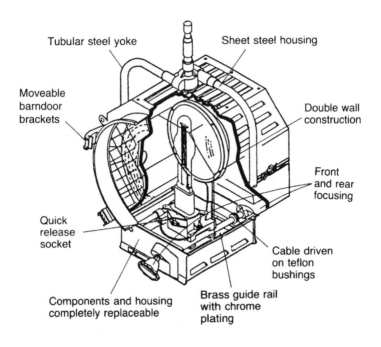

Tubular steel yoke

Sheet steel housing

Moveable barndoor brackets

Double wall construction

Front and rear focusing

Quick release socket

Cable driven on teflon bushings

Components and housing completely replaceable

Brass guide rail with chrome plating

Figure 9 Luminaire construction (courtesy of DeSisti Lighting)

Brail

To pull a lighting suspension device or piece of scenery out of its normal hanging position by means of attached rope lines.

Branch circuit (USA)

As defined by the American NEC (National Electrical Code), circuits that are downstream of the last overcurrent protection.

Branchaloris
A branch of a tree or bush held in front of a luminaire to create a moving or stationary foliage pattern.

Bridge
A narrow platform suspended over the acting area. Luminaires and projection devices mounted on the bridge are accessible during performance.

Brightness
See Luminance.

Brightness ratio
The ratio of maximum-to-minimum luminances occurring within a scene.

British Standards Institute (BSI)
Produces technical specifications and other documents which are made generally available. Most standards issued at the present time are based on standards generated within the European Community. The main aim of the Institute is to maintain standards, quality and safety in products and practices.

Broad
A wide angle floodlight. The name derives from the old term for luminaires used in the photo engraving process which were called 'broadsides'. Produces a beam which is useful for illuminating large areas such as backgrounds.

Brute
A 225 A d.c. high intensity carbon spotlight with a 24″ diameter Fresnel lens. Was the mainstay of the film industry for many years until the introduction of high power halide discharge lamps, such as the H.M.I.

Bubble
Slang term used in the television and film industries to describe lamps of any type.

Build
A gradual increase in light level or in the number of light sources used.

Bulb
An old term describing the bulbous glass envelope of an electric lamp. Is also often used to describe lamps.

Bull switch (USA)
A main switch used on the main feeder or on sub-feeder lines. It comes in 60, 100 and 300 A sizes.

Bump
To briefly flash lighting channels 'up' or 'down'.

Bus bar
Thick copper bars to which connectors are attached for electrical distribution within switchgear. Bus bars have to be carefully designed to withstand thermal and magnetic forces.

Bus bar lug (USA)
A small electrical 'G-clamp' made from brass used to attach large cables to bus bars. Has good electrical conductivity and high current rating.

Butterfly set
A frame used to support a net or silk (Butterfly) over the top of the action. The silk reduces and softens direct sunlight when shooting on location. The unit will generally cover a two shot. When covered with black Duvetyne it can be used as a giant flag.

C

C-47
A wooden spring-type clothes peg, usually used for attaching filters on lights. Bulldog clips can be also be used.

C-74
A clothes peg inverted to be used as a scrim-puller.

CCT
See Correlated colour temperature.

C.I.D. (Compact Iodide Daylight)
Metal halide discharge lamp with a correlated colour temperature of 5600 K.

CIE
Commission International de l'Eclairage. The international body which regulates standards applied to lighting, with various committees comprising representatives from all over the world.

CIE diagram
Shows the distribution of colours within the spectrum. *See Tri-stimulus and Figure 72.*

C.S.I.
A discharge lamp which approximates to sunlight for colour balance (CCT 4000 K). One of the first discharge sources with good colour rendition. Originally used for floodlighting but adapted for use in film and television.

CTB gel
A colour correction filter (CTB) which increases the colour temperature of 3200 K sources. The filters are available as follows:

Size	Colour correction (K)	Transmission (%)
Full blue	3200–5600	31
1/2	3200–4300	50
1/4	3200–3600	68

CTO gel

A colour correction filter (CTO) which decreases the colour temperature of daylight sources. The filters are available as follows:

Size	Colour correction (K)	Transmission (%)
Full orange	5600–3200	51
1/2	5600–3800	64
1/4	5600–4600	75

Cable crossover

A special ramp used to protect cable from being damaged by being run over and to prevent artists and staff from tripping over cable.

Camera light

A luminaire mounted on a camera for lighting along or near the optical axis, usually to provide catch lights for the subjects' eyes.

Cam-Lok

A type of single pole connector used for feeder cables.

Can (USA)

Permanently installed switchgear containing bus bars on a sound stage.

Candela

The unit of luminous intensity formerly known as 'candle-power'. The monochromatic radiation in a given direction of a source of 555 nm with a power of 1/680 W per steradian.

Candlepower
A term that was used for intensity but has been replaced by the candela.

Carbon arc
A d.c. arc source in which the arc is produced in air between a pair of carbon electrodes, one is positive and the other negative. The carbon rods usually have a chemical core which determines the colour output. The electrodes burn away and must be advanced during operation. The carbon arc produces about 46 lumens per watt compared with 26 lumens per watt for tungsten sources. Although arcs are noisy in operation and the burning creates smoke, the light output is considered one of the purest sources for its quality and colour. They also require a resistive ballast to control the current. Voltages across the arc for various sizes of power are in the range 40 V to 85 V. The most popular luminaire sizes were 150 A and 225 A (Brute) *(see Figure 61)*.
See Arc light.

Cathode
A negative electrode.

Catwalk
A metal or wooden walkway usually used in the film industry to provide access and additional suspension points for luminaires.

C clamp
See Hook clamp.

Celo cuke (USA)
A wire mesh painted with a random pattern and placed in front of a luminaire to throw a subtle pattern.

Chain vice grip
A mounting device that uses a bicycle chain and vice grip to create a tight clamp around pipes, poles, or branches.

Channel
The circuit from the lighting control console to its associated dimmer.

Channel number
Reference number entered by a key pad; or used by dedicated faders.

Charge coupled device (CCD)
A charge coupled device is a solid state chip covered in several hundred thousand photosensitive cells, all of this built onto a device roughly one centimetre square. As the CCDs are built to an almost perfect matrix, the geometric distortion is kept to a minimum. Each photo-sensitive cell represents one piece of picture information (*pixel*). All CCDs have the same colour sensitivity, therefore filters for the red, green and blue component have to be used. In cheaper video cameras such as domestic 'camcorders', coloured filters for the red, green and blue are integral to one CCD. Professional cameras use one CCD for each primary colour. The chips for red, green and blue have to be positioned extremely accurately so that the individual elements are aligned to an error of about half a pixel. This means the alignment must be accurate to two thousandths of a millimetre which can only be accomplished by the manufacturer. Temperature differences within the optical block could cause misregistration, due to different coefficients of thermal expansion. However, having been aligned in the factory, most systems remain relatively stable. A great advantage of CCDs is that they have a superb colour response, unfortunately with a peak sensitivity in the infrared region. This has to be corrected, other-wise there would be problems with the reds in the system, and an infrared 'cut off filter' has to be fitted to the optical path *(see Figure 10)*.

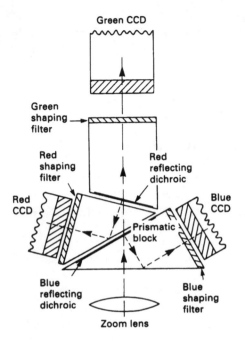

Figure 10 CCD splitter block

Chase

A series of programmed sequential steps activating channels from a lighting console.

Chaser lights

A linear string of lamps wired and controlled so that the lights appear to be following in sequence.

Chiaroscuro

A strongly contrasting treatment of light and shade in drawing and painting. Translated from the Italian, the word means 'half-revealed'. Artists who used this technique were Rembrandt and Caravaggio; in more modern times, Orson Welles' film of 'Citizen Kane' employed this technique.

Chicken coop
A lighting unit suspended over the action that provides general ambient light. Usually consists of several light sources which may be tungsten or fluorescent.

Chimera (USA)
A specially designed, lightweight, collapsible soft box manufactured by Chimera Photographic Lighting. A variety of sizes allows attachment to the front of Fresnel luminaires to produce a form of soft light.

Chroma
In television, the information which gives the colour of the image as distinct from its luminance (brightness). The chroma of a colour rises as it moves away from white, e.g. red diluted with a high proportion of white is called pink, whereas approaching its full saturation it may be described as dark or deep red.
See Munsell values.

Chroma key
A special effect which uses a monochromatic coloured background to allow electronic switching to another picture. Deep blue is commonly used for the background when the foreground involves people. Green is also used on occasions. Similar in principle to the matte process used in the film industry.

Chromaticity
The colour of light, as defined by its chromaticity co-ordinates, generally using the CIE diagram.
See Tri-stimulus.

Cinevator stand
A heavy-duty stand used for the largest types of luminaires. The mechanism that raises and lowers the luminaire is driven by an electric motor.

Circuit
1) The electrical path from a fuse or MCB to its load.
2) The electrical path from a dimmer to the luminaire.

Circuit breaker
An electrical switch positioned in the circuit that will automatically operate to break the flow of current under abnormal conditions.
See MCB, MCCB.

Circular reflector
Fresnel lens and PC luminaires use circular reflectors as they are simple and direct the reflected light rays back through the filament which is at the focal point of the reflector. Its size is dictated by the requirement to maximize light output in the flood position. The reflectors are made from super pure aluminium and have to withstand temperatures in excess of 400°C. In the case of 5 kW luminaires and above, a portion of the top of the reflector is removed to allow heat to escape and not build up on the reflector. Although the light output is maximized in the flood position, as can be seen from *Figure 11*, there is a still a high proportion of waste light and a Fresnel spotlight at its very best is only 26 per cent efficient. As can be seen from the 'spot' position, as the reflector/lamp assembly is moved away from the lens, waste light increases and rays that were arriving at the lens now miss it altogether. In the case of a tungsten lamp, which only produces 6.5 per cent of its power as light, coupled withthe inefficiency of the optical system, a Fresnel luminaire will only produce around 1.5 per cent of its input power as useful light.

Clothes line (USA)
Slang term for a suspended cable not properly fastened to the floor, posing a safety hazard.

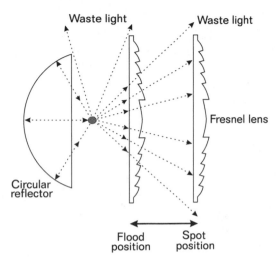

Figure 11 Circular reflector

Cmils (USA)
A Cmil is the cross-sectional area of copper wire 1/1000 of an inch in diameter.

$$\text{Area} = \frac{\pi D^2}{4} \quad \text{Area} = \frac{\pi\left(1^{-3}\right)^2}{4} = \frac{3.142^{-6}}{4} = 0.00000079 \text{ sq. ins.}$$

Cold mirror
A dichroic coated glass surface which reflects visible light but allows infrared energy to pass through the reflector so that the reflected light contains less heat. *(Figure 12)*

Colour
A sensation of light induced in the eye by electromagnetic waves of a certain frequency – the colour being determined by that frequency. *(Figure 13)*

Colour balance
Usually describes the effectiveness of film when exposed under various coloured lights, e.g. daylight film is balanced

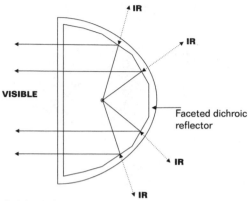

Figure 12 Cold mirror

for 5600 K light, whereas tungsten film is balanced for 3200 K. Can also describe a slight bias introduced by filters to create a warmer or cooler picture.

Colour chart

A chart of standard colours filmed at the beginning of a roll of film as a colour reference when the film is processed. This ensures accurate matching and ensures that the colour balance is always correct between the individual rolls of film. Colour charts are also used for technical line up of

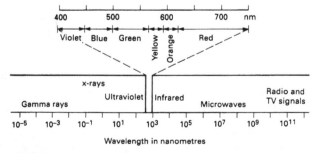

Figure 13 Electromagnetic spectrum

television cameras where all cameras in a studio point towards one chart lit by one source of light at the correct incident light level and colour temperature, e.g. 800 lux and 2950 K.

Colour compensation (CC)
A reading from a colour meter indicating the amount of green or magenta correction needed. Often used for fluorescent lights which have spectral spikes usually in the green/blue region.

Colour correction
1) The use of special filter materials to correct for:
 a) daylight to tungsten
 b) tungsten to daylight
 c) spectral aberrations in light sources.
2) Colour correction is also used for film processing to ensure that the various scenes blend together for continuity of picture quality.

Colour film
The basic system is the exposure of three layers of emulsion to red, green and blue light and this applies to both negative and reversal film. It is of course possible to individually process the red, green and blue light arriving at the film by using three separate film stocks, and this was the basis of the old Technicolor system used from 1932 to 1955. One of the problems with using three different stocks for the red, green and blue components is that although it is easy to separate the constituent colours, the superimposition of the three images to reproduce the final image is somewhat difficult and requires a high degree of precision. Even with the Technicolor process, the final copy of film sent to the cinemas for projection was multi-layer film stock.

With film rated for a certain sensitivity and a fixed lighting level, the only way to control the correct exposure is by

varying the lens iris or shutter speed. With film cameras the shutter speeds are certain fixed values, e.g. 24 frames per second. For greater sensitivity when the lens is at its maximum aperture, it is necessary to change to a different type of film. As a general rule, the more sensitive film becomes, the greater is the granular structure. The reason for using larger grains in the film is that they stand a higher chance of being struck by the photons. The use of a larger grain structure reduces the sharpness of the image.

The exposure of film to light causes the photons to strike the silver halide crystals in the film emulsion and these will change according to the intensity of the light. Photographic emulsion is naturally sensitive to the blue part of the spectrum; to increase the sensitivity to the green and red layers sensitizing dyes have to be added to the emulsion. By using the basic emulsion as the top layer in the system, it will be sensitive to the blue part of the spectrum and, because of this, no filter is needed for the blue input from the lens. Because of the sensitivity of the other two layers to the blue, it is necessary to reduce the blue going through the film by having a yellow filter immediately beneath the top layer. If the bottom layer is made sensitive only to red light, a red filter is not needed. Between the yellow filter and the red emulsion is the green emulsion. As the blue light has been prevented from reaching this emulsion, which is sensitive only to the green part of the spectrum, a green filter is not required. By constructing the film this way, effectively there have been three single exposures for the red, green and blue but all taken at the same time and in perfect register. Also by allowing the longest wavelengths to travel the furthest through the layers, light scatter is reduced, which is one of the causes of lack of resolution.

The film is now processed so that cyan, magenta and yellow images are formed in the three layers. This is typical of negative film stock. To produce the positive from this stock, it

is basically only necessary to photograph it with a similar type of negative, although in practice very sophisticated films can be used for the reversal process. Films can be balanced for artificial light or daylight and this is accomplished by the balance between the red and blue emulsion sensitivity.

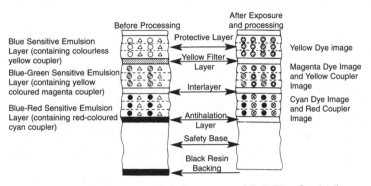

Figure 14 Colour film emulsion (courtesy of Fuji Film Co. Ltd)

Colour filter

A translucent material used to change the colour, and quantity, of light passing through it. The original filters were made from gelatine – hence all filters tend to be known as 'gels'.

Modern filters are manufactured from high grade plastics and glass. In the case of filters for cameras, heat is not a problem, however this is not the case for filters used in front of lights. With tungsten luminaires of 2 kW and above it is usually necessary to have stand off colour frames to prevent the filter from bleaching and burning.

The filters required in the lighting industry either change the colour of the light source or change the colour of the viewed image as seen by television, film or photographic cameras.

A good filter should only be interested in the visual energy, i.e. that from 400 nm to 700 nm. A perfect filter would

precisely remove that portion of energy at the correct wavelength. Filters cannot be made with the sharp cut-off required and generally have some form of overlap and thus remove other portions of the light beam. When light falls on any material, three things occur: some light will be reflected, if the material is translucent enough some light will pass through the material, and some of the light will be absorbed within the material. The absorbed light will be converted to heat energy. When the majority of the light is either reflected or transmitted the heating effect will be fairly low. Therefore filters such as 'Pale Straw' will virtually absorb no energy whereas a 'Deep Blue' will absorb a high proportion of red and infrared and thus get very hot. It is usual when testing for the effect of light beams on coloured gels to use the blue range due to their energy absorption property. The majority of gels are produced for tungsten lighting, therefore the filters are modifying light in the range 2700 K–3200 K. All filters have a *mired shift* which produces different results according to the incident light colour. It has to be remembered that a filter called 'Bright Rose' looks decidedly not 'Bright Rose' when put in front of a predominantly blue source.
See also Subtractive colour mixing and Mired.

Colour frame
A frame used to support colour media at the front of the luminaire. To hold the filter material it is necessary to provide fine wire supports and these can cause projected shadows if not positioned correctly – generally a diamond pattern prevents problems.

Colour meter
The colour of light emitted from a discharge lamp cannot be expressed in Kelvins because the spectral output in the lamp is not continuous but dependent on the gases and rare earths used in its manufacture to introduce the required additional

colours which help to create the colour of the source; and the compounds used emit colours in only comparatively narrow bands. In photographic and television cameras the film stock and the colour receptors are responsive to the amounts of red, green and blue in the light, but unfortunately due to the spiky nature of the colour distribution from a discharge lamp a standard colour meter that measures only the red/blue balance of a source will give erroneous readings because it is not measuring the total spectral output.

In the theatre the lights are rigged and set for visual effect, whereas in film and television accurate measurements of incident light onto subjects are required. Measurements of colour temperature are also required when using sources that approximate to the blackbody curve. It is essential to measure colour of any type, particularly when operating discharge sources. A tri-stimulus meter contains three photo cells which are filtered to detect the primary stimulus values of blue, green and red light under a special opal diffuser. This diffuser is specially made to take account of the direction of light and therefore inherently calculates the cosine angle of incident light. The incident light level can be derived from the output of the green photo cell as this relates to the photopic curve. To obtain the colour temperature of a source, meters of this type will compute a point on the spectrum locus from an analysis of the red, blue and green receptors. To ascertain colour shifts it is possible to use the 'x' and 'y' co-ordinates to refer to the CIE spectral diagram.

Colour rendering index (Ra)

The evaluation of the effect of a light source on a set of coloured test pieces representing portions of the visible spectrum. The higher the Index towards its maximum of '100' the better the colour reproduction. Sources in general require an Index greater than '90' to prevent noticeable colour distortion.

CIE general colour
rendering
index (Ra) **Typical application**
Greater than 90 Where accurate colour matching is required,
 e.g. colour print inspection.

80 to 90 Where accurate colour judgements are
 necessary and/or good colour rendering is
 required for reasons of appearance, e.g. shops
 and other commercial premises.

60 to 80 Where moderate colour rendering is required.

40 to 60 Where colour rendering is of little significance
 but marked distortion of colour is
 unacceptable.

20 to 40 Where colour rendering is of no importance
 and marked distortion of colour is acceptable.

Note: For film or TV an Ra index of at least 80 is required.

Colour scroller

A device fitted as an add-on extra to a luminaire to provide a
colour changing system. Usually consists of around sixteen
colours glued together and activated by a motor in linear
motion and controlled by a digital input signal. Can give noise
problems due to the motor drive and colour changing is
relatively slow.

Colour temperature

A method of specifying the colour of a source which emits
light in a continuous spectrum. Expressed in Kelvin units, the
range used in lighting is from 2600 K (white light with a high
red content) to 6000 K (white light with a high blue content).
Cannot be used with discharge sources, although sometimes
used as a guide to approximation of colour. Many sources of
light energy do not have the same characteristics as
blackbody radiators, but sources which have a mainly white
light output can be given a correlated colour temperature.

This is defined as that temperature of the blackbody radiator which most closely matches that of the light source in question. It therefore gives a rough guide to the blueness or redness of the source. Sources plotted along the blackbody curve will shift either to red or blue, however when the shift is away from the curve it will go towards either green or magenta. The human eye is not too perturbed by a magenta shift which is, of course, a mixture of red and blue, whereas a shift to green is very noticeable.

Blackbody radiation	Colour temperature (K)
Extremely dull red	753
Very dark red	903
Dark red	1023
Cherry red	1088
Light cherry red	1173
Orange red	1263
Orange	1423
Yellow	1603
Candle flame	1900
Dawn or dusk	2000–2500
Tungsten halogen lamps	3200
Photo flood lamps	3400
1 hour after sunrise	3500
Late afternoon sunlight	4500
Summer sunlight	4800–5000
3200 K lamps with dichroic filter	4800–5600
FAY lamps	5000
Sunlight with blue/white sky	6500
Summer shade	7000
Overcast sky	7000
Skylight	10 000–20 000

Source	Cor. colour temperature (K)
White fluorescent lamps	3500
H.M.I.	5600
Xenon	6000

Colour wheel
A circular mechanism holding several different colours mounted in front of a luminaire which can be rotated by hand or by a motor drive. These devices have been largely superseded by modern automated luminaires where the control of colour is internal to the housing with a wider range of colour output.

Combo stand (USA)
A junior stand with a 1 1/8″ receptacle used to hold reflector boards and larger luminaires.

Complementary colours
Pair of colours which combine to make white light, e.g. Cyan + Red, Yellow + Blue, Magenta + Green.

Condenser
A lens or mirror used in an optical system to collect the light being radiated from a source, which is then directed onto the gate of the projection system.

Condor (USA)
A vehicle with a telescoping boom arm used as a platform to position luminaires 30–120′ in the air.

Console
Name for a control desk (derived from 'organ console').

Contactor
An electrical switch used within an electrical system to control the on/off state of the supply. Usually operated by an electromagnetic coil. Contactors for high current operation may be immersed in oil to quench 'arc-over' when being operated.

Continuity tester

A device that runs a small amount of current through a conductor and lights a small bulb or makes a sound if the conductor is continuous.

Contrast range

This is the ratio of the brightness between the lightest and darkest areas in a subject. In a video system, it is the range between the maximum signal which can be satisfactorily handled without distortion and the acceptable electronic noise level of the system.

Contrast ratio

The ratio of the intensity of the key light plus the fill light to the intensity of the fill light alone.

Converter

A device for converting a.c. to d.c. or vice versa. Can also be used to change the frequency of supply.

Cookie (USA)

See Cucaloris.

Correlated colour temperature (CCT)

Many sources of light energy do not have the same characteristics as blackbody radiators, but sources which have a mainly white light output can be given a correlated colour temperature. This is defined as that temperature of the blackbody radiator which <u>most closely</u> matches that of the light source in question. It therefore gives a rough guide to the blueness or redness of the source.

Cosine law

The equation which allows the calculation of illumination on a surface which is at an angle to the incident light.

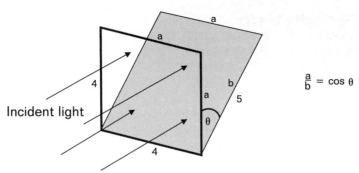

Figure 15 Cosine law

Clearly (b) is longer, therefore the hatched area is larger,

e.g. original area $= a^2 = 4 \times 4 = 16$
 new area $= a \times b = 4 \times 5 = 20$
Also 16/20 $= 0.8 = \cos \theta$

$I = 10{,}000$ candela

Light level
$I/5^2 \times \cos \theta$
$= \dfrac{10000 \times 0.8}{25}$
$= 320$ lux

$\theta = 37°$

Figure 16 Incident light angle

When the incident light falling on a surface is at 90° to the plane of the surface, a light meter will correctly measure the incident light *(Figure 17, Diagram A)*. The amount of light measured will change when the light approaches at any angle other than normal. This variation in light is related to the cosine of the angle of the incident light away from the normal and is known as 'Lambert's cosine law'. The reason that this

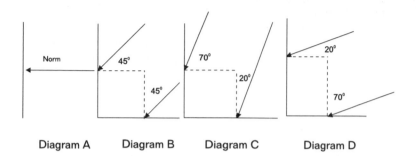

Diagram A Diagram B Diagram C Diagram D

Figure 17 Effect of incident angle

happens is that the light has to cover a greater area when striking from any angle other than normal. A follow spot produces a round beam of light when projected straight ahead, but when pointed at an angle to an artist on the stage, the beam adopts an elongated shape. The amount of light in the beam has not changed, but the area covered has increased; thus the amount of light per unit area diminishes. Obviously, if the beam is elongated more and more as the light approaches from increasingly shallow angles, the area covered by the light beam becomes virtually infinite. Thus the amount of light per unit area becomes less and less and approaches zero. The formula used is light level × cosine of angle of incidence to the normal, I Cos θ

In *Diagram B* of *Figure 17* it will be seen that light falls on the vertical and horizontal surfaces at 45° and both surfaces will be affected in the same way. However, *Diagram C* shows the light incident at 20° to the normal on the horizontal surface and incident at 70° to the normal on the vertical surface. The light arriving at the horizontal surface will be modified by the cosine of 20° = 0.94, and at the vertical surface by the cosine of 70° = 0.34. Thus 94 per cent of the light reaches the horizontal surface and only 34 per cent

reaches the vertical. **Diagram D shows the complete opposite** where the vertical receives 94 per cent of the light and the horizontal gets only 34 per cent.

Film and television are generally concerned with vertical illumination whereas the floodlighting fraternity concern themselves with the horizontal. In practice it is essential to know what light level is to be measured, i.e. vertical or horizontal. Most modern light meters are provided with cosine corrected cells so they do give an accurate measurement of the light level, taking into account the various angles of incidence from any combination of light sources.

Counterweight system

Mechanical system for flying scenery in which the weight of the pieces of scenery is balanced by adjustable weights in a cradle running up and down in guides in a frame, normally at the side of the stage. The system is also used for lighting bars.

The most basic of these systems is to use a long barrel with the adjustment of height made by a counterweight system. In the theatre, these consist of very long barrels up to 10 m long, slung from several wire ropes. The lights are all at the same height and the weight on the barrel can be considerable when the power cables are attached. The counterweight system allows for the weight of the barrel, plus all the luminaires and cables mounted on it, to be balanced by a selection of special iron weights and provides an easy method of raising and lowering barrels with heavy loads. Counterweight barrels are mainly used in the theatre; although they have been used in some television studios, due to their length, they cannot provide the flexibility of other systems for this application.

Cove (Coving)

Portable scenery placed on floor with a curved section to

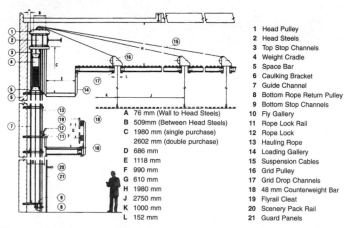

A	76 mm (Wall to Head Steels)
B	509mm (Between Head Steels)
C	1980 mm (single purchase)
	2602 mm (double purchase)
D	686 mm
E	1118 mm
F	990 mm
G	610 mm
H	1980 mm
J	2750 mm
K	1000 mm
L	152 mm

1 Head Pulley
2 Head Steels
3 Top Stop Channels
4 Weight Cradle
5 Space Bar
6 Caulking Bracket
7 Guide Channel
8 Bottom Rope Return Pulley
9 Bottom Stop Channels
10 Fly Gallery
11 Rope Lock Rail
12 Rope Lock
13 Hauling Rope
14 Loading Gallery
15 Suspension Cables
16 Grid Pulley
17 Grid Drop Channels
18 48 mm Counterweight Bar
19 Flyrail Cleat
20 Scenery Pack Rail
21 Guard Panels

Figure 18 Counterweight system

allow a visual smooth transition between the floor and cycloramas. Main purpose in television is to hide groundrow cyc units. The film industry usually provide deeper coving constructed on set by the plasterers and immediately adjacent to the vertical surface.

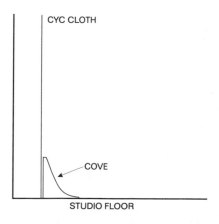

Figure 19 Coving

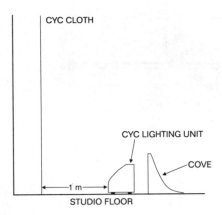

CYC CLOTH

CYC LIGHTING UNIT

COVE

←—1 m—→

STUDIO FLOOR

Figure 20 Cove and groundrow

Crank-up stand
A heavy duty stand provided with gears and a cranked lever
to raise and lower heavy luminaires.

Cribbing (USA)
Blocks of wood used to level camera tracks, lighting stands
and props.

Croney cone
Luminaire attachment which is cone shaped and fitted with a
diffuser to soften and control the beam.

Cross barrel
Used between lighting bars to allow accurate positioning of
luminaires. Cross barrels are usually suspended by safety
bonds at a variety of angles between two bars. An important
point to remember is that each attachment to a lighting bar
imposes extra weight, and on occasions may give problems
with the Safe Working Load of the individual lighting bars.

A safety problem occurs where one of the supporting bars
is raised in isolation, hence the cross barrel is raised at one
end only, causing the luminaires to either slide down the

barrel or swing out of position causing damage. To prevent this, it is normal practice to carefully mark any control systems for rigged cross barrels.

Cross fade
A gradual change in the lighting where one lighting set-up *completely* replaces another. Obviously, only one cross fade can occur at a time.
See Move fade.

Cross key lighting
Illumination from two luminaires at approximately 180° to each other on opposite sides of the subject. They are generally hard sources.
See Key light.

Crowder hanger (USA)
A luminaire mount that fastens to the top of a set and provides two spigot holders (studs).

C-stand (USA)
A multipurpose floor stand used for grip equipment to position flags and nets to shade areas of the set or subjects. Short for Century stand.

Cube tap (USA)
A device that allows three Edison plugs to plug into one Edison socket.

Cucaloris
A cut-out pattern placed in front of a luminaire to create a pattern.

Cue
1) A signal, which may be written, verbal or by action, that causes motivation of artists or technical staff.
2) Refers to changes in the lighting set-up.

Cue light
1) A flashing or rotating light positioned outside the studio/set to warn people when a film take is happening. In television, during rehearsals, blue lights indicate activity and red lights indicate transmission or recording conditions.
2) To activate the performer at a specified moment.

Cue number
The reference number given to control system memories which contain the lighting set-up information.

Cup blocks
Wooden blocks (5 1/2″ square) with concave indentations. They are usually used under the wheels of lighting stands to prevent them rolling away.

Current
The rate of flow of electricity measured in amperes.

$$I = \frac{V}{R}$$

where I = current in amperes, V = applied voltage and R = resistance. With a.c., resistance is replaced by impedance (Z) or reactance ($X_L X_C$).

Cutter
A long, thin flag used to block portions of the light beam.

Cyclorama
A backing, mounted in the studio, to provide a continuous surface and an illusion of infinity. Cloth cycloramas, due to their size, are made from several pieces of cloth and it is essential that the seams are not noticeable. To prevent the seams being visible on camera it is usual to light the cloth to very high levels and crush detail. In practice, although a cloth cyclorama may be tightly stretched, it is still possible for

movement to be created by air flow from air conditioning systems.
See Cove.

Cyclorama (Cyc) lights *(Cyc strip)*

A set of open faced luminaires used to light a cyclorama. The luminaires are supplied as single-, twin- or four-way units.

With groundrow units, the reflector is designed to direct as much light as it can towards the top of the cyclorama, with the bottom of the cyclorama lit by direct light from the lamp. Owing to the inverse square law and the cosine law, it is always difficult to project enough light to the top of the cyclorama. Bottom cyclorama units are normally placed with the front of the unit 1 m from the cyc and in a continuous row. If colour mixing is used with red/green/blue and white, the colours repeat every 1.2 m. Top cyc lighting units are normally rigged approximately 3 m from the cyc and at 2.5 m intervals, giving a more even coverage of the cyc from heights as great as 10 m. This is due to the distance of the units from the cyc. In small TV studios, it is possible to provide an even coverage on a cyc cloth, up to 5 m high, with the units at 1.2 m intervals and 1.2 m from the cyc. As their normal operating distance has been reduced, the 1250 W lamps can be replaced with 625 W lamps.

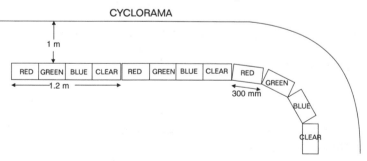

Figure 21 Groundrow cyc units

Bottom units normally utilize 625 W linear lamps and top units use 1250 W linear lamps. In both cases, the lamps should be frosted which prevents the projection of filament supports and other striations on to the cyc.

The colour frames usually have 'tiger teeth' along the edge to break up the shadows created by the linear lamp filament being in line with the inside edge of the colour frame. Cyclorama lighting systems can use many dimmer circuits,

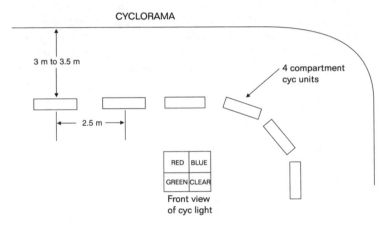

CYCLORAMA

3 m to 3.5 m

2.5 m

4 compartment cyc units

| RED | BLUE |
| GREEN | CLEAR |

Front view
of cyc light

Figure 22 Top cyc units

therefore it is necessary to provide distribution systems to operate several units from one dimmer. The number of units being dictated by the individual dimmer output power.

Space for overhead cyc luminaires is always difficult to find due to their physical size. When rigged on lighting barrels at the edge of the studio, all units have to be at the same height to give the correct coverage. This can create a problem with backlights rigged on the same barrels.

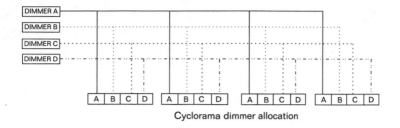

Cyclorama dimmer allocation

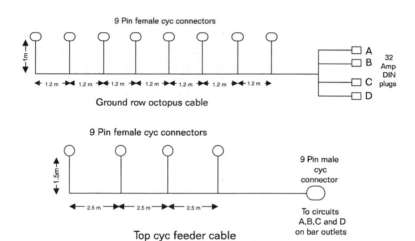

Ground row octopus cable

Top cyc feeder cable

Figure 23 Cyclorama distribution systems

D

DC (also d.c.)
See Direct current.

DMX
Multiplex protocol for transmitting digital information from control consoles to dimmers and automated luminaires. DMX 512 is the most used and when the system requires more than 512 control circuits, further DMX 512s have to be used.

Daylight
Light commonly considered to have a colour temperature between 5500 K and 6000 K. Daylight-balanced film renders colours naturally when lit with 5600 K light. Towards the Poles of the planet, daylight will probably be of a higher colour temperature and require filter correction.

Daylight filter
1) A blue filter used to change the colour of a light source from tungsten at 3200 K to approximately 5600 K.
2) A blue filter used on a camera to allow daylight balanced film stock to be used with tungsten lighting.

Dedolight
A small, special lightweight luminaire with a wide range of beam angle adjustments. Provides very high light level output, generally using low volt lamps.

Delta-connected system
A system that provides a three phase supply where the coils are connected to form the Greek letter delta (Δ). With a centre tapped neutral used, which is common in American systems, one leg of the supply will be higher in voltage than the others due to being across one and a half coils of the transformer.

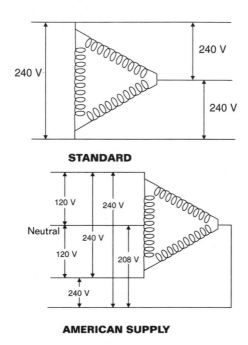

STANDARD

AMERICAN SUPPLY

Figure 24 Delta (Δ) supply system

Depth of field

The depth of the scene that will appear to be in focus on the perceived image. Depth of field varies with the following:

1) lens aperture – as the lens is stopped down, i.e. toward a larger f-number, depth increases
2) focal length – as focal length increases, depth decreases
3) distance from the subject – the greater the distance the better the depth
4) image format (size of film or CCD) – the smaller the image the greater the depth.

When viewing a projected picture, the depth reduces as the image is enlarged.

Deuce (USA)
A 2 kW Fresnel luminaire.

Deuce board (USA)
A fused a.c./d.c. distribution unit having two high current contactors that can be controlled from remote switches.

Devitrification
The process which causes a change from a 'glassy' state to a crystalline state. This is particularly noticeable with quartz lamps when they have been contaminated on their surface. When handled and not cleaned, it is possible for fingerprints to appear on the quartz surface if lamp manufacturers' recommendations are not followed.

Dichroic filter
A filter which reflects chosen wavelengths and transmits the remainder. Usually used for 3200 K to 5600 K colour correction. Will not fade as a normal plastic filter would, but can be damaged by chemicals. Being on a glass substrate they are also subject to fracture and can be a safety hazard. Used carefully they are superior to plastic filters and can be mounted immediately on the front of a luminaire, whereas a plastic filter will have to be stood off by a reasonable distance. Specialized dichroic filters are made to reduce infrared and ultraviolet for lighting works of art.

Diffuser
Sheets of frosted plastic or spun glass fibre used to soften the shadows produced by the light beam. The frosted plastic can also have lines etched which act as miniature lenses and bias the light passing through in specific directions.

Dimmer
Dimmers can be resistive, inductive or electronic. Their main purpose is to reduce current flow to a lamp and therefore allow its light intensity to be adjusted. As a source is dimmed

its colour temperature will reduce towards red in the case of tungsten lamps. Discharge and fluorescent lamps can be dimmed by electronic dimmers over a <u>specified range</u> without significant colour change. Discharge lamps have the opposite characteristic to tungsten lamps and become bluer when dimmed.

Resistance dimmers are still used in the film industry, usually on d.c. systems. Inductive dimmers have been used in the past but were superseded by the thyristor dimmer.

The majority of dimmers use thyristor devices. Because the thyristor is a unidirectional device, two have to be used to control the positive and negative half cycles of the a.c. supply. A close cousin of the thyristor is the 'triac'. Whereas the thyristor is unidirectional, the triac is a bidirectional device and, by applying a signal to the gate, it is possible to obtain full wave control of a.c. power. There are several advantages to using solid state devices such as the SCR and triac: the power loss is exceedingly small, they are very easily controlled and, most important of all, they are independent of the load across them. The major drawback to solid state switching devices is the fact that the period of time from its 'off' state to its 'on' state is extremely small, in fact of the order of microseconds, and it is this switching cycle that gives problems in practice. The thyristor dimmer output, as can be seen from *Figure 25*, chops the wave form into discrete quantities.

The method of operation requires that the control signal for a dimmer is varied from the control console and the dimmers are switched on at some time during the positive and negative half cycles. Thyristors depend on a flow of current to keep them activated. There is a minimum current required to maintain this conducting state and when the current drops below this value, which is known as the 'holding current', the thyristor will stop conduction and become effectively an open circuit. It is therefore essential that this minimum current flows

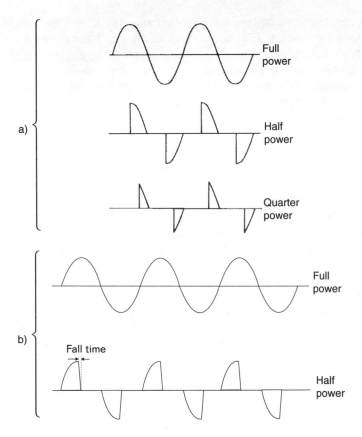

Figure 25 a) Thyristor waveforms; b) IGBT waveforms

so that thyristor circuits are stable. Small resistive and inductive loads often can cause dimmers to become unstable. When lamps switch on, the current flowing through a cold filament may be up to fifteen times greater than the normal current. Thus a 5 kW studio Fresnel spotlight with a normal steady state current of around 21 A on a 240 V supply, could have a cold inrush current of anything up to 300 A.

Therefore, the thyristor has to be rated for a greater current level than would normally be expected.

In practice, most thyristor dimmers are operated at about 80 per cent of their full output and this is enough to guarantee that there will always be a rapidly rising current waveform which is the switch-on point of the negative and positive half cycles, and all dimmer manufacturers have to take special precautions to reduce this rise time from a few microseconds to between 300 and 1000 milliseconds, which reduces the generated interference. The simplest method, and the one most often used, is to place a choke in series with the dimmer output.

The dimmer output waveform can cause vibration to be set up in lamp filaments every half cycle which manifests itself in a high-pitched buzzing – colloquially known as *lamp sing*.

Several modern dimmers use Insulated Gate Bipolar Transistors to regulate the current and it is possible with these devices to control the switch-off period and reduce the rate of fall of current, and hence the amount of interference generated. This avoids the need for a choke in the output and reduces the weight of the dimmer quite significantly. This type of dimmer works in an opposite manner to thyristor control, always switching on at the zero point, and then switching off at some point during the subsequent half cycle. A typical IGBT dimmer takes 1200 milliseconds to go from maximum to zero when switched off (fall time), each half cycle, and this is sufficient to avoid interference problems and lamp sing.

See Rise time.

Dimmer curve

A graph which shows the light output or voltage output of a dimmer against the channel control setting. Modern dimmers are programmed to give various output curves and most

consoles are capable of shaping dimmer laws. The normal television law provides for a square law light output where the square of the fader setting gives the percentage light output, e.g. Fader at '8' equals light output of 64 per cent.

Fader setting	Output volts			Current	Power	Light	Col. temp.
	240	120	%	%	%	%	K
10	240	120	100	100	100	100	3200
9	224	112	93	96	89	81	3120
8	211	106	88	93	82	64	3040
7	194	97	81	88	72	49	2960
6	178	89	74	85	63	36	2860
5	158	79	66	78	52	25	2750
4	142	71	59	73	43	16	2600
3	122	61	51	67	34	9	2400
2	94	47	39	59	23	4	2200
1	55	27	23	46	11	1	–

Dimmer room
The area which has been allocated for the equipment racks which contain the dimmers and associated equipment. Will generally require air conditioning as most dimmers will each generate between 50 and 100 W of heat. With older thyristor dimmers using chokes for interference suppression, there may be acoustic noise problems.

Dinkie
A small Fresnel luminaire which nowadays has been largely superseded by Dedolights which give a much higher light output.

Dip-less cross fade
When channels with the same level in different lighting set-ups do not vary in intensity during a cross fade.

Direct current (d.c., also DC)

Current that does not alternate in polarity. Alternating current varies in both positive and negative directions with regard to zero (earth/neutral) each cycle. Direct current will stay steady in relation to zero (earth) and will be polarized either positively or negatively.

Director of Photography (DP)

The person in charge of the lighting and camera departments. The DP has direct creative control of the image.

Discharge sources

In all types of discharge lamp an arc is struck between two electrodes in an envelope containing an inert gas or vapour. A choke or electronic ballast is used in the supply to limit the flow of current after the arc has been established. The arc is struck by applying a high voltage across the electrodes to break down the resistance between them so that the gases or vapours inside the lamp will conduct. Typical cold starting voltages are between 2000 V and 10 000 V. From ignition the lamp normally takes 1–2 minutes to reach its correct output.

It can take from 2 to 5 minutes to allow a hot lamp to cool to a point where it can be re-ignited, due to the internal pressure. Lamps are also designed so that they can be struck when hot, using a voltage between 20 000 V and 70 000 V to overcome the high internal pressure.

Discharge lamps are made using mercury, halides, rare earths and gases; often containing a mixture of many types of chemicals. There are some 40 metal halides to choose from and each manufacturer uses various types to give a characteristic light output. Iodides of sodium produce mainly yellow light, mercury emits blue/green light in the visible parts of the spectrum and a great quantity of invisible radiation in the ultraviolet wavelengths. Thallium is used because it emits mainly green light.

The most popular discharge sources are:

Note: the following sources require an a.c. supply

Name	Manufacturer	Efficacy Lumens/watt	Colour temp. K
HMI	Osram	95	5600
HMI/SE	Osram	95	5600
MSR	Philips	95	5600
MEI	Osram	95	5600
GEMI	G E Lighting	95	5600
CID	G E Lighting	70–80	5500
CSI	G E Lighting	90	4000
SN	Philips	60	5500
DAYMAX	ICL, USA	95	5600
BRITE ARC	Sylvania, USA	95	5600

Note: the following sources are fed from d.c. supplies

EMI (Xenon)	G E Lighting	40	6000
XBO (Xenon)	Osram	40	6000

Discharge lamps emit large quantities of UV radiation which pass straight through quartz envelopes; it is, therefore, most dangerous to be directly exposed to the lamp. It must always be housed or have a lens or protective glass in front of it. Borosilicate glass Fresnel lenses are opaque to UV and therefore prevent any radiation. Open faced luminaires require a safety glass be provided to prevent UV radiation. Safety standards require that a switch is fitted to the lens door or safety glass to automatically extinguish the lamp, thus preventing UV exposure to the operators and artists. Alternatively, the lens door or glass must be securely fastened so it cannot be opened accidentally. Manufacturers have to design discharge luminaires so that no direct UV leaves the housing, either via openings in the body or lens housing.

Figure 26 Discharge lamp

Discontinuous spectrum

A light source with a discontinuous spectrum, such as a fluorescent lamp, that does not emit light evenly across the colour spectrum, but instead has spikes at particular wavelengths and emits little or no light at others, resulting in poor colour rendering.

Distribution box

An electrical box with circuit protection, such as fuses or MCBs, which is used to change from mains circuits to sub circuits, providing an assortment of socket types. Usually called 'Distro box'.

Distribution system

The distribution systems can be for production lighting, general lighting and power supplied for cameras, audio equipment, various types of technical equipment and associated services such as wardrobe, make up, scenery, etc.

The power will be either from the public supply or from a generator and the distribution system will feed dimmers and other subsidiary equipment, which may be located in many

Figure 27 Location lighting distribution system

places within the temporary installation. It is essential that all feeds to all these items of equipment are adequately fused or have the correct MCBs fitted to ensure protection for the cables and equipment.

Generally, multi-core connectors and cables are used for circuits up to 125 A, above this point single core connections are generally used. An important factor with the cable rating is that cables may be taken to areas where the temperatures are extremely high and, due to the installations, will probably be bunched or grouped in close proximity which can cause problems, this is a factor which must be taken into account by the designer concerned. All items used on the temporary installation should have been tested for electrical safety prior to being delivered to site; they should be marked that the test was satisfactory. The electrical distribution units are required to be in safe areas and inaccessible to the public. When routing the cables, it is essential when in public-access areas that the cables are routed carefully, possibly up and over gangways, so that there is no danger of anyone tripping over cables.

Dog collar (USA)
A short length of aircraft cable used to secure luminaires hung above the set. The collar is fitted with a loop at one end and a clip or karabiner at the other. Known as Safety bond in Europe.
See Safety bond.

Dolly grip (USA)
The grip in charge of laying dolly track and executing dolly moves and crane moves.

Dot
A very small, circular flag, net, or silk used to alter only a small portion of the beam of light.

Double broad
This is a twin lamp floodlight generally used on studio floors as a local filler.

Double purchase
A suspension system used on counterweight bars which gears the movement of the counterweight bucket to half that of the bar itself.
See Single purchase.

Double scrim
See Scrim.

Doughnut effect
The aberration in the centre of a luminaire's projected beam associated with Plano-Convex lens systems, follow spots and open faced luminaires, caused by the positioning of the lamp within the optical system.

Douser *(Dowser)*
A small metal flag used in follow spots to cut off the light beam without having to switch off the electrical supply to the source.

Down-fade
The portion of a fade that involves only channels that are decreasing in level.

Downlighter
Usually refers to small ceiling mounted luminaires in control room areas.

Downstage
The stage or studio area which is nearest the audience.

Dress a light
To tidy up the luminaire and/or its cable.

Drop
A 'flat' or canvas curtain painted with a scenic background usually used at the rear of the 'set' behind windows, etc.

Drop arm *(Trombone)*
A device used to hang a luminaire lower than the normal suspension system permits. Allows the luminaires to be positioned at differing heights on lighting bars. Drop arms can be of fixed length, e.g. 0.5 m, 1.0 m, 1.5 m or variable in length where one tube slides inside another and holes are provided at 150 mm intervals to fix steel pins, thus providing a variety of heights. In confined spaces, very much more useful than pantographs.

Duck bill (USA)
A vice grip with a 5/8 in. male spigot on the handle and two 6 in. sq. plates welded to the jaws. Used to mount foamcore and bead board on a C-stand.

Dummy load
It is sometimes necessary to provide an electrical load to be able to test equipment. For example, when testing dimmers the load could be a resistance rather than a luminaire.

Dummy loads are also used to balance electrical circuits for power distribution.
See also Ghost load.

Duvetyne
Thick, black cloth used to block the light beam.

E

Ears
The metal brackets on the front of a luminaire that hold the barndoors and scrims.
See Bracket.

Earth (Earth continuity conductor)
A conductor bonded to earth, other than the neutral, to provide a safety connection for metal components which are not in the electrical circuit. It is accepted to be the point of zero potential.

Effects
1) Lighting to provide atmosphere.
2) Sequence of lighting, usually pre-programmed to give a visual effect (chasers etc.).

Effects projector
A focusing luminaire used to project slides or shapes. The effects can also be motor driven.

The gate is designed to accept a conventional photographic slide or a large piece of glass with the scene to be projected painted onto it. It is therefore possible to make a photographic slide of the actual backing required from the correct position to give the correct perspective and then project it onto a white backing. An alternative accessory is a rotating disk positioned on the front of the projector with the appropriate effect painted onto the rotating glass, i.e. rain, fire, snow, etc. In this way a moving effect can be created at variable speed. A choice of objective lenses are made available to give the coverage required at the appropriate distance. Disadvantages are the high cost of the projectors and high effects costs, together with comparatively low light output levels that cannot compete with high lighting levels on

the TV and film set. A very steady mount is required, as any vibration will ruin the effect.

Figure 28 Effects projector

Efficacy

This is the efficiency of a light source in converting the electrical input power to the total amount of lumens generated and is expressed in 'lumens per watt'. In practice, luminaires are not 100 per cent efficient and therefore do not use the total lumens generated.
See Efficiency.

Efficiency

This is a measure of the <u>useful</u> light output in lumens against the total lumens generated by the light source. The useful light output is dependent upon the size of light source and the optical system which collects and redirects the light through the lens. In practice, the nearest sources of illumination to point sources are discharge lamps, particularly the xenon. Most tungsten lamps have a fairly large source area, due to their construction, and therefore cannot be positioned at the focal point of the mirror. This is one of the

reasons that tungsten spotlights are very inefficient. Fresnel and PC spotlights are unable to focus all the light from the source onto the lens and are particularly wasteful in the spot position. Some modern effects luminaires are designed with very compact filaments which produce the same light output as older luminaires using twice the wattage. The 575 W tungsten lamps are fitted with heat sinks on the pinch to enable them to be used at high temperatures in specially designed reflectors. With tungsten lamps of a higher wattage it is virtually impossible to keep to a compact filament design.

Egg-crate
A device consisting of small cross baffle plates to restrict the spread of the light beam on a soft light.
See Louvres.

Electrician
Common name for a lighting technician.
See Sparks.

Electromagnetic spectrum
Electromagnetic waves consist of radio waves, infrared, the visible portion of the spectrum, ultraviolet (UV), x-rays and gamma rays. The only parts of the spectrum of interest are infrared, visible and UV. Infrared is invisible and produces a sensation of heat, but fortunately with no adverse side effects. Most of the lights used radiate energy in the infrared region, tungsten being particularly wasteful from this viewpoint. Higher energy sources such as discharge lamps have less infrared but more UV.

UV is also invisible to human beings but, unfortunately, in significant amounts is extremely harmful. The tungsten filament in lamps radiates a white light around 3000 K. To produce ultraviolet radiation in significant amounts, temperatures of 3500 K and higher are required. Temperatures around 6000 K are found in mercury vapour

lamps, such as fluorescents, xenons and professional lighting discharge lamps and they all emit large amounts of ultraviolet radiation.
See Colour.

Electronic ballast
A solid-state ballast. The term electronic ballast is synonymous with flicker-free low frequency square-wave ballasts for discharge sources such as the H.M.I., or high frequency units for fluorescent discharge sources.
See Ballast and Square wave.

Ellipsoidal spotlight (USA) (Europe: Profile projector) A luminaire which uses an ellipsoidal reflector and a reasonable quality optical system to project shapes and patterns with a hard edge. Also called a Leko (USA). These units are provided with either fixed optics or zoom optics and most units in use today are of the zoom type. To obtain good efficiency from the optics the beam angles of any single unit are restricted to 2:1, e.g. 15–28°. The range of typical beam angles is from 5° to 45°. The beam is shaped by using either four shutters or an iris capable of being focused from a sharp image to a diffused shape. These luminaires are the mainstay of theatre lighting. For TV and photography it is used as a gobo projector for backgrounds. Because the housing is very long, particularly on narrow angle units, this can prove a problem in restricted rigging space and adjacent scenery can sway and knock it out of position.

Elliptical reflector
With the source placed at the first focal point, the reflected light is directed to the second focal point adjacent to the lens. The elliptical reflector system is comparatively efficient compared with the true radius reflector but it still suffers the losses shown in *Figure 29*. There is a finite limit to the size of the reflector because

making it larger does not allow the reflected light to be directed onto the lens system.

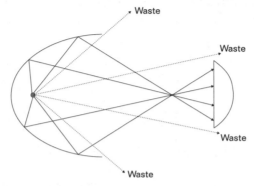

Figure 29 Elliptical reflector

Elvis
Gold lamé stretched on a frame and used to bounce light.

Equipment grounding (USA) (Europe: Equipment earth)
The grounding of conductive parts of equipment, such as the outer metal casing, via a green grounding wire. *(Europe: Green/yellow stripes).*

Ethernet
Data transmission system for computer networks; also used for interconnection of lighting consoles, dimmers and VDUs in remote locations.
See DMX.

Expendables
Supplies, such as tape, that are used up during the course of a production.

Extension bar
This is used to extend lighting barrels for accurate positioning of luminaires.

Extension cable

Used where the luminaire cable is too short to reach the nearest source of power. Generally three-core, although for high current applications may be several single core cables.

Eye

The majority of people see the world as a high definition colour system, even when requiring glasses for optical correction. Unlike film and TV cameras, human beings have a variable exposure system with an iris and auto control of sensitivity and do not suffer from crushed blacks or over exposed whites.

However, a major problem with the eye is that it can be fooled; it is not an absolute measuring instrument such as a colour meter, but relies mainly on comparative measurements to assess information. Attempts to memorize a colour and trying to achieve a colour match later invariably cause a problem. However, two colours when shown side by side have only to vary by a minuscule amount and the difference is noticeable. As humans process visual information using superior intelligence, the human eye does not have to be as good as that of many birds and animals.

Light, upon entering the eye, is received by 'rods' and 'cones' on the back of the retina. The cones which number approximately seven million, are for the detailed full colour examination of objects in bright light; the rods, which number approximately one hundred and thirty million, are for the examination of objects in low light conditions.

Owing to the complexity of connections between the rods and cones and the optic nerve, there are around 140 million photoreceptors connected to about 1 million fibres in the optic nerve, with a much higher number of rods in relation to the cones. As several rods work together into one nerve to increase low light sensitivity, the low light acuity of vision is poor. The cones have lower density which means signals are

passed with higher resolution. Owing to the cones' lower
sensitivity, it is necessary to do fine detail work in high light
levels when the cones are working efficiently.

Figure 30 Cones' sensitivity

In 1801 Thomas Young suggested that the eye contained
three colour receptors. It was also reasoned that to provide
the correct colour information signals the range of
wavelengths for the *red, green and blue* receptors would
have to overlap each other to some degree and it was only
during the 20th century that scientists discovered the true
response of the rods and cones to the colour of light.

The photoreceptors can only respond by changing their
voltage which gives no absolute information as to the colour
of the stimulus that caused the change. For the eye to assess
accurately the colour and pass the information to the brain,
nerve cells from differing colour receptors must be stimulated
so that the relative amounts of colour energy in the viewed
scene can be assessed. Thus a stimulation of a *red receptor*
and a *green receptor* will give a result between pale yellow
and deep orange, depending upon the balance of the two
receptors.

Information from the eyes travels to the primary visual

cortex at the back of the brain and the information it requires is as follows:

Motion Form Depth Colour

Motion is perceived as a primary safety signal to the brain, and this is generally processed in black and white. Form or shape, which gives information describing the scene, is generally required with colour. Finally, two eyes provide depth and the three-dimensional image that gives shapes of objects, etc. However, humans can be tricked by perspective so additional information is required. Generally this is produced by shading, for example, old silent movies illuminated largely in flat lighting, do not have the depth that the later monochrome studio films had in the 1940s and 1950s and, in fact, it was this process that enabled black and white television to have some depth, due to the use of light and shade.

The images presenting themselves to the brain give little or no meaning. 'Meaning' is using memory stored from previous encounters and checking that the image entering the brain corresponds to the stored information. For example, when viewing an apple, memory tells us that it contains seeds; you do not actually need to see them to produce this information. Recognizing a person's face requires both the image to the brain and the memory stored of the information regarding the face. For example, the eyes can be functioning perfectly correctly and give the correct image to the brain, but if the memory system has a fault, such as may have occurred in a person who has suffered a stroke, recognition is faulty and almost impossible. Recent experiments suggest that the back of the brain is like a miniature television screen and that, when using imagination, an image in this area is produced, thus 'seeing' gives the same result to the brain as imagination. Whilst seeing we are comparing the incoming scene with the memory system, which provides additional

information about the perceived scene and fills in what is not seen but what our memory says must be there.

It must be always remembered that colour matching can only occur by direct visual stimulation and not by memory. This is the main reason that systems such as the CIE diagram and Munsell charts are essential to anyone involved in lighting.

See Photopic curve.

Eye light
Used to create a twinkle in the eye of the subject.

F

FPS (Frames Per Second)

Film is normally shot at 24 frames per second. Television in countries with 50 Hz supplies uses 50 frames per second which is interlaced to 25 pictures per second. In countries with 60 Hz supplies, television uses 60 frames per second and a picture rate of 30.

F-number *(f-stop)*

The 'f-number' is the measurement of the <u>theoretical</u> amount of light that can pass through a lens. It is also colloquially known as the 'stop'. To obtain the f-number of a lens, the focal length is divided by the diameter of the aperture. Thus, a 50 mm lens which has an aperture 25 mm wide, will be an f2 lens. The following are typical f-stops found on lenses:

f1, f1.4, f2, f2.8, f4, f5.6, f8, f11, f16, f22, f32

Each of the above divisions is 'one stop'. The reciprocal of the square of the f-number, it gives the amount of light passing through the lens, i.e. $1/stop^2$.

Note: The transmissions given are for perfect lenses and do not include optical loss.

f-no.	f-no^2	$\dfrac{1}{f-no^2}$	Transmission %
1	1	1	100.0
1.4	2	1/2	50.0
2	4	1/4	25.0
2.8	8	1/8	12.5
4	16	1/16	6.25
5.6	32	1/32	3.13
8	64	1/64	1.56
11	122	1/122	0.78

(*continued*)

f-no.	f–no^2	$\dfrac{1}{\text{f–no}^2}$	Transmission %
16	256	1/256	0.39
22	484	1/484	0.20
32	1024	1/1024	0.10
64	4096	1/4096	0.05

Fade
A gradual change in light levels from one set of intensities to another.

Fade time
The time between the start and end of a lighting change. Can vary between a few seconds and anything up to 60 minutes; occasionally the time may be over a longer period in theatrical productions.

Fader
A control device for indirectly setting the current output of a dimmer and thus varying the light intensity. Originally were levers, but are often 'wheels' in modern lighting control systems.

Fall-off
The diminishing intensity of light across the beam of a luminaire. Also, the reduction in light output over distance due to the inverse square law.

FAY
An incandescent PAR lamp with dichroic coating that creates daylight-coloured light.

Feeder cable
Large single-conductor cable or multi-core cable used to run power from the power source to distribution boxes on the set. *See Extension cable and Distribution system.*

Field angle

Those points on the light output curve which are 10 per cent of maximum output. The included angle between these two points is the field angle.

See Beam, Beam angle and Figure 6.

Filament

The tungsten coil inside a lamp that glows when voltage is applied to it, creating light. The melting point of tungsten is 3370°C, which is 3643 K. Tungsten lamps made for 3200 K operation are obviously very close to the melting point and therefore have relatively short lives compared with those made for lower colour temperatures. The radiation from a tungsten filament is largely infrared, with only approximately 6 per cent producing visible light.

See Figure 45.

Figure 31 Output of 500 W tungsten lamp

Filler (fill light)

Light used to control shade areas. Usually a soft light but can be controlled hard light.

Film speed

1) A measure of the film's sensitivity to light expressed in numerical terms to give an 'exposure index' which is used in the ISO and ASA system on light meters.

2) The velocity of film passing through movie cameras or

projectors and is measured in frames per second or in metres per minute.

See ASA.

Finger
A very small rectangular flag, net or silk, used to control small portions of the light beam.

Five K
A colloquial term for a five kilowatt spotlight.

Fixture (USA)
General term for a luminaire, light, or lantern.

Flag
A sheet of metal or card mounted in front of a luminaire to give a relatively sharp cut-off to the light beam. The cut-off is dependent upon the distance from the luminaire and improves as the distance increases. Very effective with focused luminaires such as the Fresnel but when used with open faced luminaires often requires greater distances to achieve sharp cut-off. Also black Duvetyne cloth stretched over a metal frame.

Flag box
A wooden box in which flags, nets, and silks are stored.

FLB filter
A filter used to remove the green hue of fluorescents.

Flex arm
A small jointed arm used to hold fingers and dots.

Flicker
Light flicker is caused by the light following the mains frequency from zero to a maximum value and back down to zero again. With tungsten lamps the inertia of the heating effect in the filament damps out the mains frequency variations. In the case of discharge sources there are

noticeable dips in the light output at the zero crossover points of the supply. This causes a flicker at twice mains frequency when the discharge source is controlled by a choke ballast unit. If a camera is synchronized to the frequency of the light source then the exposure will be the same for successive pictures. When a camera is not in sync some frames will be exposed to the 'peak' light output, whereas others will be exposed during the 'dips' in the light output. The effect on camera is of correctly exposed frames interspersed with under-exposed frames and this exhibits itself as a series of pulsations called 'flicker'.

However, the problems can be overcome by the use of an electronic square wave ballast. By using very fast switching times between the positive and negative half cycles, the current 'OFF' period is very small compared with the current 'ON' period; consequently the light output appears to be constant, and the user does not have to worry about any synchronization for the various shutter angles of film cameras and the time-bases of TV systems.

See Flicker-free ballast and Shutter.

Figure 32 Safe mains supply frequencies – 24 FPS

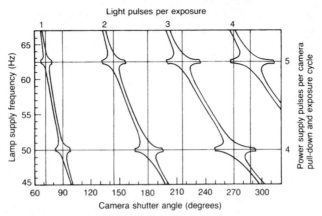

Figure 33 Safe mains supply frequencies – 25 FPS

Flicker box

A control device used to simulate the flickering of a flame or television screen. A flicker box randomly increases and decreases the intensity of the light output of the luminaires.

Flicker-free ballast

A solid-state ballast that provides square waves of around 100 Hz with rapid switching between negative and positive cycles, to eliminate variations in the light output of discharge sources, thus avoiding problems with synchronization of film shutters and television field frequencies.
See Flicker and Ballast.

Flood

By focusing a lamp close to a lens, the diameter of the light beam is enlarged and thus gives the widest field of illumination. This is the most efficient position for Fresnel and PC lenses.
See Spot.

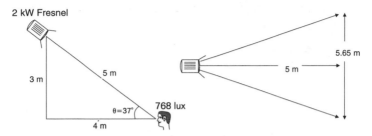

Figure 34 2 kW spotlight in flood position

Floodlights

1) Floodlights used in entertainment lighting produce wide angle illumination which is difficult to control. Barndoors will not cut off the beam because of the large area of the source and reflected light. They are hardly ever used in television, except for house or working lights, and in the theatre limited in use to large areas of colour wash. The advantages are a very wide angle and high efficiency because most of the light is projected out of the housing. The units are usually low cost. The same principle of an open faced reflector is used in the portable 'Redhead', refined by moving the lamp to give spot and flood focusing. The disadvantages of poor barndoor control are tolerated in favour of the high light output, small size and weight.
See Softlight and Cyclorama lights.
2) Floodlights used in sport and large arenas are more controlled sources of illumination and, due to the distances involved, have to be narrow angle focused beams. The beam angle is generally dependent upon the distance of throw from its mounting to the light beam's position on the playing surface. Discharge sources are nearly always used due to their greater efficacy. The

colour rendering of the discharge sources generally has to be in excess of 80 owing to the fact that television and film will often cover events lit with floodlighting.

Fluorescence

The ability of some materials to convert ultraviolet energy into visible light.

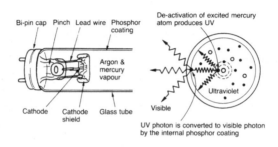

Figure 35 Fluorescent lamp

Fluorescent lamps

A fluorescent lamp produces light by the effect of phosphorescence. The arc discharges through low pressure mercury vapour and generates ultraviolet with a small amount of blue light. The phosphor coating on the inner surface of the glass tube converts this ultraviolet energy into visible light and the colour perceived depends upon the type of phosphors used. When light sources which use phosphorescence are switched off, there is a short 'afterglow', therefore, the use of phosphors smooths out some of the variations in the light output.

The light output is affected by the temperature of the lamp, due to varying the internal vapour pressure of the gas in the tube. Lamps are usually designed to operate in an ambient temperature of around 20°C and if the lamp runs hot, or indeed cold, a lower light output results.

Fluorescents normally run from 50 Hz or 60 Hz supplies, but there are great advantages in increasing the frequency of operation. The efficacy (lumens per watt) of fluorescent lamps is increased by about 10 per cent by increasing the frequency from the normal mains to between 20 kHz and anything up to 100 kHz. However, the increase in efficacy is less at frequencies in excess of 30 kHz, therefore this is the normal region for high frequency operation. A benefit of using frequencies around 30 kHz gives the advantage that it is outside the audible range and below frequencies at which losses in the electronic ballast system would become noticeable. Owing to a reduced power consumption in a high frequency system, the temperature in luminaires will be lower than those at normal mains frequencies. By using high frequency electronic ballasts it is possible to reduce the amount of flicker which is normally noticeable in mains operated ballasts. This has the advantage of overcoming the stroboscopic problems with moving machinery or fast moving subjects, and obviously can be a great advantage when using film or TV cameras. Nowadays, a whole range of compact fluorescent lamps is produced, with each lamp folded in half, with the ends connected to a single lamp cap. Various phosphors are used to give good colour rendering with a choice of colours. By using high frequency ballasts, it is possible to achieve very high efficacies.

Typical efficacies are as follows:

40 W tubular range	– 100 lumens per watt
55 W compact bi-axial	– 85 lumens per watt
36 W compact bi-axial	– 80 lumens per watt
26 W compact quad	– 70 lumens per watt

Warm White Fluorescent characteristics (Data from Philips' catalogue)

Lamp type	Lamp length (mm)	Lamp diam. (mm)	Watts	Colour rendition	Lumen output	Lumens per W
Standard	1514	36	65–80	Moderate	5400	67–83
TL'D	1514	25	58	Moderate	4600	79
TL'5 High Efficient[1]	1463	15	35	Very good	3650	104
TL'5 High Output[1]	1463	15	49	Very good	4900	100

[1] Electronic ballast

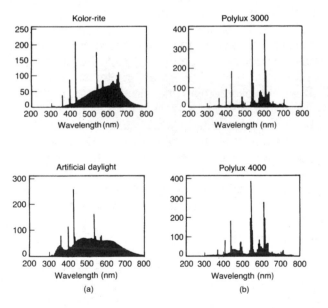

Figure 36 Fluorescent characteristics a) Standard and b) triphosphor

Fly

To suspend scenery or equipment above a stage or studio floor by means of a suspension system which can be manually operated or driven by motorized units.

Fly gallery

The gallery which extends around the side walls of the stage area approximately 10 m above the stage floor. It is used for operating the ropes which adjust the counterweight system and hence the height of the bars above the stage.

Fly tower

The upper part of the stage area which is formed as a tower, usually with galleries, to suspend scenery out of sight of the audience. Also known as 'the flies'.

Foamcore (USA)

A white, glossy card material reinforced with 1/4″ Styrofoam and used to bounce light.

Focal length

The distance of the focal point from the lens is called the focal length of the lens. For camera lenses, it is usually expressed in millimetres. A long lens has a very narrow angle of view and a short depth of field. A short lens has a wide angle of view and greater depth of field.

Focal point

The point where the incident parallel rays, which are bent by a lens, meet in focus.

Focal spot (USA)

An accessory that mounts on a Fresnel luminaire, essentially changing the luminaire into an ellipsoidal spotlight.

Focus

In optics, the adjustment to give a clearly defined image. Originally used in the lighting industry to indicate the process

of 'spotting' or 'flooding' the light beam of a luminaire, but is now used to indicate the general setting of a luminaire on the stage or in a 'pop' rig.

Focusing reflector light

The best example of a focusing reflector light is the 'Redhead' which is used in interview situations because of the high light output from a small unit. A degree of focus is achieved by moving the lamp in relation to the reflector. When the lamp is moved into the spot position the reflector provides increased intensity in the centre of the beam while the overall total light output angle remains practically the same because of the direct illumination from the filament. Although the output from the fairly compact filament gives a hard shadow, the barndoor performance is very poor due to the luminaire's optics. A safety glass or mesh has to be provided to prevent quartz from the envelope causing danger in the event of the lamp shattering. The standards require that particles 3 mm or more shall not escape from the housing.

Follow spot

A narrow angle, focusing hard edged spotlight used to follow moving artists.

Optically the follow spot is very similar to an Ellipsoidal (Profile) projector. Instead of four shaping shutters, it has two horizontal blades and a single lever operates them, producing a variable parallel slot of light known as 'Chinese'. The blades can close completely, giving a blackout known as a 'dowser'. The unit also contains an iris diaphragm to control the spot size. By introducing another iris diaphragm into the light path where it cannot be focused, it is possible to dim the light without changing the colour temperature or the shape of the spot. It is also possible to dim the output by fitting four triangular blades similar to a barndoor to the front of the follow spot where they will not be in focus. When all four blades are fully open the light will not be attenuated but as

the blades close together, towards the front lens, the light dims.

Foot-candle

An old unit, now superseded by 'lux', used to describe illumination which was measured in 'lumens per square foot'. Still used by the film industry in the UK and Hollywood.

One foot candle is defined as the amount of light falling on an area of one square foot at a uniform distance of one foot from a source of one candela. The principle is the same for one lux, which is defined as the amount of light falling on an area of one square metre at a uniform distance of one metre from a source of one candela.

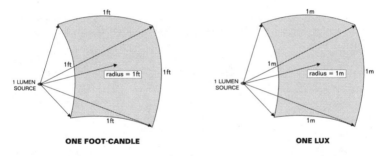

Figure 37 Foot-candles and lux

The relationship between foot candles and lux is simply the difference in area. As there are 3.28 ft to the metre, there are $3.28^2 = 10.76$ sq. ft. to the square metre. So, one foot candle simply becomes 10.76 lux.

Foot-Lambert

One foot-Lambert equals the uniform brightness of a perfectly diffusing surface emitting or reflecting light at a rate of one lumen per sq. ft. It is the oid unit for luminance (brightness) which has been officially replaced by the 'nit'.

The nit is defined as a luminance of 1 candela/m^2 .

Footlights
Lights that used to be provided along the edge of a stage to give uplighting. Now largely abandoned due to modern theatrical techniques and presentation.

Frequency
The number of cycles per second of an a.c. supply, measured in Hertz (Hz).

Fresnel lens
A convex lens built with concentric steps to enable its thickness to be reduced. This has two effects, one of which is to make it considerably lighter and the other is to reduce the heat differential from centre to edge of the lens *(see Figure 11)*.

Figure 38 Fresnel lens and spotlight

Fresnel spotlight (colloq. Fresnel)
Luminaires fitted with Fresnel lenses of varying sizes. The size of lens generally being dictated by the power output of

the lamp, e.g. a 1 kW lens will be very much smaller than a 5 kW although both may have the same optical characteristics.

The luminaire is fitted with a circular reflector with the lamp placed at the centre of radius of the reflector. To focus the light, the lamp and reflector are moved together. Maximum flood is achieved when the source is nearest to the lens, and the spot position of focus is when the source is at the focal point of the lens. The beam width is typically from 8–60°. One great advantage of the Fresnel output is the gradual fall off at the edge of the beam which allows various Fresnel beams to be evenly blended when overlapped. One problem with the Fresnel is that if the lens is not carefully designed, there can be obvious light scatter from the risers on each zone of the lens. This can be very troublesome when lights are placed close to sets, where the light scatter exhibits itself as projected concentric circles.

Fringing
Chromatic aberration in simple lenses creating dispersed colour effects around the light beam, similar to the colours of a rainbow in appearance, blue being the most predominant of the colours.

Front of house lights (FOH)
Luminaires usually mounted on barrels, and generally concealed, above the stalls audience seating. They are sometimes mounted in special galleries to allow easy physical adjustment and rigging.

Frost
Plastic filters used to diffuse light sources, soften hard edges of light beams and reduce the effects of hot spots in the beam.

Furniture clamp (USA)
An adjustable clamp used for mounting luminaires.

Furniture pad (USA)

A packing blanket used to protect floors, deaden sound, soften a fall, and so on.

Fuse

A protective device for electrical circuits; originally a piece of special wire but nowadays nearly always a metal link contained in a ceramic cartridge. They are designed for specific voltages and current ratings. The voltage ratings are high, low and miniature application use. For high voltage applications the fuses are often liquid-filled so that when the fuse element melts, the resulting arc is extinguished very rapidly. Fuses for normal mains operation are made with silver fuse elements although plated copper is also used. It is important that the materials used have a high resistance to oxidation so that the fuse does not deteriorate during its life.

Fuses are designed to withstand very high fault currents, as an example fuses to BS 88 are rated for 80 kA.

G

Gaffer

Term mainly used in the film industry to describe the chief lighting technician. The gaffer works directly under the Lighting Director (LD). His duties will include organizing the lighting, generators, distribution system and grip equipment required. During rehearsals he will direct a team of electricians to rig and set luminaires as required by the Lighting Director/Director of Photography. A most important task is to ensure the smooth running of the lighting system so no time is lost – which invariably results in extra cost.

Gaffer clamp/grip

A clamp with two jaws fitted with rubber pads and equipped with a mounting spigot to temporarily attach fittings to scenery flats, suitable horizontal and vertical surfaces and lighting equipment, e.g. lighting barrel.
See Mafer clamp.

Gaffer tape

Heavy, fabric-based tape that rips cleanly in the direction of the weave. It is used for securing cables and luminaires on the set.

Gamma

A measure of the contrast in image reproduction.
1) In television, overall gamma relates to the receiver screen luminance and the brightness of the original scene.
2) A graph that describes a film emulsion's reaction to tonal gradation and its innate *contrast*. Also called D log E curve or characteristic curve.

Gang box (USA)

An outlet box fitted with Edison sockets which plugs into a

larger connection box, such as a 60 A Bates or a 100 A stage box.

Gate
The optical centre of a profile projector where the shutters are positioned and an iris or 'gobo' can be inserted.
See Shutter.

Gator grip
See Gaffer clamp/grip.

Gel
See Colour filter.

Gel frame
A metal frame that holds gels or diffusion material which slide into the bracket at the front of a luminaire. With high powered luminaires, the colour frames have to be further away from the lens and hence larger in area. The problem is much less for discharge sources than it is for tungsten with their infrared output.

Generators
A diesel powered unit used to generate power on location (also used in some film studios). They are sound baffled and provide either bus bars or other feeder connectors. Also called 'genny'.

Generators come in various sizes, from small Honda sets giving a few kilowatts to large 1000 kVA generators. All modern generators are driven by diesel units and are provided with large fuel tanks so that the generator can run for many hours without being replenished. One of the problems with diesels is that if they run out of fuel, it would be necessary to bleed the fuel lines to allow the diesel to run again. On occasions, when it is necessary to run generators for long periods of time without switching off, it may be necessary to make special arrangements to introduce fuel

from an external fuel tank system. The generators are normally three-phase and require that the phases are fairly well balanced to ensure that the diesel runs smoothly; the diesels used for the entertainment industry require to be silent running. It is essential that the frequency of supply is kept stable, and this is usually done by fitting electronic governor systems. Normally, the rear of the generator contains a distribution panel which is fitted with voltmeters, ammeters and the various switches required to run the diesel itself. The normal procedure is to wire the generator from the local distribution units, check all the electrical system is OK and safe and then run the generator; when the generator is running the main switches are applied and electricity is supplied to the system.

Although a generator may be rated at, say, 1000 kVA, if this is not feeding units which have a good power factor, the output will be considerably reduced and, when using discharge sources with standard ballasts, a 1000 kVA generator may be only worth 700 kVA with all the luminaires connected.

Ghost load

A load that is not used to light the set and is placed on a circuit to balance the various legs of power or to bring the load on a resistance-type dimmer up to its minimum operating wattage. Also called *dummy load* and *phantom load*.

Glare

The light sensitivity of the eye usually adapts itself to the illumination. A good example of this is coming from a fairly dark room into very bright sunlight and it doesn't take very long to adjust to the new conditions, although the light levels are incredibly different.

Adaptation requires a period of time to work and, in fact, it requires a long time to get used to dark after light (more than

30 minutes), but on the other hand it does not take long to be accustomed to light after dark. There are limits to adaptation and this can be when luminance is so great that glare can occur. Reading from white paper in a full summer sun, where the luminance value may be as high as 25 000 candela/m^2, is very uncomfortable. What causes this problem? In fact, it is because the eye is not a perfect optical instrument and is affected by the scattering of the light rays which causes a high intensity source to be seen as if it were surrounded by haze. Where part of the retina is suddenly illuminated, the whole retina drops very rapidly in sensitivity (within 0.1 second). A good example of this is looking at a window which occupies part of the viewed scene which causes the eye to decrease in sensitivity and although the window may be reasonably clear, the remainder of the environment becomes rather dark. Both of the above effects are very well known to the average motorist, either driving during the day when the road surface may reflect very bright areas, or indeed at night, with the headlights of oncoming vehicles. Unfortunately, it takes some time for eyes to re-adjust to normal after looking at sources which give us glare problems. There are two forms of glare; the first, which impairs the visual performance, is called 'disability glare' and the second, which can cause visual discomfort, is called 'discomfort glare'.

Disability glare is caused by a bright source in the field of view, whereas discomfort glare is caused by excessively bright areas in the field of view and is usually caused by too high a difference between the dark areas and the bright areas being viewed. Generally, the luminance differences in the field of vision should not exceed 10 to 1. A good example of discomfort glare is looking at a bright sky to see what type of aeroplane is going over with the sun on the edge of the field of view. Generally, eyes need to be shaded from the glare of the sun – by a hand, hat or paper.

Globe (USA)
A lamp or bulb.

Gnats _(Gnats whisker)_ (USA: Scosh)
Slang term used in the UK to describe a very small amount.

Gobo
A mask placed in the gate of a profile spot to shape the beam. It is a simple form of outline projection.

Gobo arm
The arm which can be attached to a gobo head on a stand on which to mount gobos. Typical lengths of arm are 500 mm and 1 m.

Gobo head
The metal knuckle that attaches the gobo arm to a stand. The unit consists of two metal plates with grooves to hold various sizes of arms, e.g. 1/4″, 3/8″, 1/2″ and 5/8″.

Grandmaster
The device _(wheel or fader)_ which has overall control of the output of a lighting console. The name derives from the days of mechanically coupled dimmers where the individual dimmers were set to the desired level, and then grouped onto a main drive shaft, thus allowing a series of dimmers to be activated together.

Greens (USA)
The wooden catwalk suspended above the set in a sound stage.

Grey scale
A series of steps from black to white which allows contrast ranges to be measured and used for assessment of gamma correction. Is also used in television to align cameras.

Figure 39 Grey scale

Grid
1) (USA) A transformer unit used with a carbon arc light.
2) The structure of metal tubes suspended above the stage floor for hanging luminaires.
See Lighting grid.

Grid clamp
A clamp that attaches to standard lighting grid barrels (48 mm OD). Several varieties are available for either bottom fixing or side fixing to the bar together with various configurations for suspension. Two typical examples are shown in *Figures 40* and *41*.
See Hook clamp.

Figure 40 Male barrel clamp (courtesy of Doughty Engineering Ltd)

Grid cloth
A white nylon diffusion fabric with a grid-like weave. A similar filter material is also available.

Figure 41 Female barrel clamp (courtesy of Doughty Engineering Ltd)

Griffolyn

Trade name for plastic material. Griffolyn sheets come in 6' × 6', 12' × 12' and 20' × 20' available in black/white, white/white and clear. They are used as a bounce for fill. Also called griff.

Grip

A crew member responsible for the non-electrical aspects of lighting and rigging, and also operating camera dollies.

Grip clip

A metal spring clamp resembling a large clothes peg and used to clamp various materials together, e.g. tensioning cloths across wooden battens.

Grip truck (USA)

The lighting truck that houses the luminaires and grip equipment during location shooting. Will hold a considerable array of equipment, some of which is there 'just in case'.

Ground fault interrupter (GFI) (USA)

A special type of circuit protection. There are a number of different types of GFI. One type compares the outgoing

current of a circuit with the returning current. If it detects a difference in the two (indicating a ground fault), it trips a switch to disconnect the circuit. They are also called Ground Fault Circuit Interrupters (GFCI).
See also RCD.

Grounded wire (USA)
The grounded, white, current-carrying wire (neutral) of an American a.c. circuit. (**Note**: Do not confuse this term with the *green grounding wire*).

Grounding wire (USA)
The green, equipment-grounding wire of an a.c. circuit.
See Earth.

Groundrow
A lighting unit with multiple compartments, usually arranged in linear fashion, for lighting from the base of cyclorama. The normal lamp used for even coverage is a 625 W frosted. Although more light would be available by using 1250 W lamps, the fact that the coloured gels are suspended over the lamp normally precludes this wattage. The units are provided as single-, twin- or four-way. The four-way unit is used for colour mixing fitted with red, blue and green filters, with the fourth compartment clear to dilute the colour output. A cove normally hides them from view.
See Cyclorama (Cyc) lights, Cove.

H

H.M.I. (Hydrargyrum (Latin for mercury) **M**edium arc length **I**odides)
Discharge lamps which have a daylight colour balance (5600 K). Owing to their colour output, which has a very good colour rendering factor and high efficacy, they have become the workhorse of location lighting in the film and TV industries.
See Discharge sources and C.I.D. and M.S.R.

Half scrim
A semi-circular scrim used to attenuate part of the light beam. Can be supplied as single and double attenuators.
See Scrim.

Halogen
The group of chemical elements, iodine, bromine, chlorine and fluorine. The gases of these elements are used in tungsten lamps to improve their light output characteristics. Iodine was originally used in lamp manufacture and is the least active of the halogens; its main disadvantage was the production of a pale magenta cast. Tungsten halogen lamps currently use bromine which, although slightly toxic, produces a neutral light output.
Note: The toxicity from individual lamps is negligible, but should a large number become broken simultaneously the risk is obviously much greater.

Halogen cycle
When a tungsten filament is burning, atoms leave the filament and attach themselves to the inside surface of the lamp. This is most noticeable in the household bulb, which becomes quite black by the end of its life. Theatre and studio lamps had the same problem, resulting in the reduction of both light and colour temperature throughout their life. The first halogen lamps appeared in the early 1960s using a quartz envelope

and an iodine filling. The new development was called Quartz Iodine but unfortunately had a slight magenta colour when hot. Eventually the lamp manufacturers used bromine in place of iodine and a synthetic hard glass in place of pure quartz. In general, the more reactive the halide, the more effective is the halogen cycle. So, in theory, fluorine, the most reactive, should be the best but it is so reactive that it even attacks the glass or quartz. Therefore iodine, bromine and chlorine are the only ones in use for halogen lamps. Owing to the fact that lamps were produced with quartz and glass envelopes, tungsten filaments and various halogens, the name 'tungsten halogen' was introduced as a generic term.

Tungsten atoms 'boil off' and leave the filament; as they cool down below 1400°C they combine with the halogen atoms and circulate within the lamp envelope. If the temperature fell below 250°C they would separate. However, by moving the envelope closer to the filament, thus maintaining a higher temperature, the compound will not separate. So the tungsten and halogen atoms circulate, in a convection effect, until they find a temperature above 1400°C (the filament), when the compound separates and deposits the tungsten atoms back onto the filament.

The above implies that the life of the lamp is infinite but, in practice, there are minuscule variations of thickness in the filament and the tungsten atoms are redeposited unevenly. Eventually, therefore, weak areas develop on the filament and ultimately cause lamp failure.

It would appear that a problem might occur when a tungsten halogen lamp is dimmed to a very low level, due to the fact it becomes cooler. However, in practice, the evaporation from the filament is substantially reduced and the small amount that does deposit on the envelope is removed when the lamp temperature is restored to full.

Tungsten halogen sources do generate a small amount of ultraviolet radiation and quartz envelopes will allow the

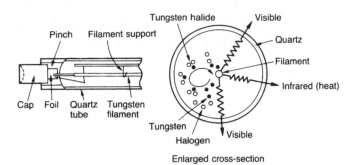

Figure 42 Halogen cycle

ultraviolet rays to pass through. This can cause a similar effect to sunburn. If the skin is exposed continuously for 4–5 hours with a light level of 2000 lux, a slight reddening of the skin will occur with a 3200 K lamp. At half this light level, 1000 lux, the time could be doubled. The problem only applies to luminaires which are not using a Fresnel lens or safety glass, because glass is a good UV filter.
See Ultraviolet.

Hard glass halogen lamp
A tungsten halogen lamp with an envelope of borosilicate glass.

Hard light
A luminaire that produces well defined shadows, normally a spotlight. One of the best sources for well defined shadows is the carbon arc, although these days, discharge sources run it a close second.

Harmonic distortion
When a wave shape departs from being purely sinusoidal with a sharp rise or fall in its characteristic, such as a square wave or the chopped wave form produced from thyristor dimmers, it will contain harmonics of the original frequency. Normal three-phase supplies under balanced load conditions

have no current in the neutral. It would appear that the harmonics would also produce a similar result, however this is not the case and triplet harmonics such as 3rd, 6th, 9th, 12th etc., do not cancel out. The most troublesome harmonic, due to its magnitude, is the 3rd as can be seen from *Figure 43*.
See Dimmer and Ballast.

Figure 43 Harmonic distortion

Head (USA: Light fixture)
A luminaire.

Head cable
The power and control multi-core cable which connects the ballast to a discharge source luminaire. The plugs and sockets used vary in size and pin configuration according to the various manufacturers and the power requirements.

Heat filter
A filter which removes infrared from the light beam to reduce heat from the source of illumination. Filters are also produced

to prohibit infrared and UV. These are often used when filming in art galleries and museums to prevent light rays from luminaires damaging works of art.

Hertz (Hz)
The unit of frequency which is measured in cycles per second. Other units are kilohertz (kHz) and megahertz (MHz).

Hi boy (USA)
An extra tall stand for mounting luminaires.

High key
Describes a scene containing mainly light tones well illuminated without large areas of strong shadow.

High leg (USA)
The 208 V leg of a delta-connected three-phase system.
See Delta-connected system.

High roller (USA)
An extra tall rolling stand, often used to fly an overhead frame.

Highest takes precedence (HTP)
On a lighting control system, where the highest setting will win, when two or more pre-set levels are simultaneously selected for that channel. E.g. if '7' then '5' are selected for a particular channel, '7' will win.
See Latest takes precedence.

Hoist
Old term used to describe either manual or motorized lifting equipment.
See Winch.

Hook clamp
A clamp used for suspending luminaires from lighting bars.
See C clamp.

Figure 44 Hook clamp (C clamp) (courtesy of Doughty Engineering Ltd)

Hot spot

1) Usually produced by luminaire optical systems not using Fresnel lenses. The beam centre of PCs and some effects units are prone to hot spots unless the lamp is carefully focused or the manufacturer takes steps to prevent problems in practice.

2) A shiny spot or glare reflection that is distracting to the eye.

House electrician

An electrician permanently employed by a theatre or concert hall to maintain and operate the electrical equipment in the premises.
See Sparks.

House lights

A lighting system permanently installed to either illuminate an audience area or provide work lights in studios.

Housing

The metal casing that encloses the lamp, reflector and optical system of a luminaire.

Hue

The quality by which one colour is distinguished from another as a result of their wavelengths, e.g. blue and green. It does not take into account the brightness or intensity of the colour.

I

ISO
See ASA.

Illuminance
The luminous flux falling on unit area of a surface. The international unit of illumination is the lux (1 lumen/m^2) and it is the measure of the quantity of <u>incident light</u>.
See Foot-candle and Lux.

Impedance (Symbol: Z)
A measure, in ohms, of the opposition to current flow in an a.c. circuit. Impedance includes resistance, capacitive reactance and inductive reactance.

Incandescence
The emission of light by raising a material to a high temperature. Tungsten is used for incandescent lamps due to its high melting point of 3370°C (3643 K).

Incident light
See Illuminance and Lux

Incident light meter
Incident light measurements only account for the light falling on a subject, and therefore are not influenced by the subject matter. A good modern incident light meter should be capable of measuring the illuminance in either lux or foot-candles. In addition, it's much better if the meter has a digital readout so the figures are accurately displayed. The spectral response must match the CIE photopic curve which gives the correct balance for incident light readings.

 When measuring incident light, it is essential that a cosine-corrected cell is used which gives readings which are correct and take into account the angle of the light incident on the

meter. It is also important that the meter is facing the direction of the camera taking the scene.

Independent
Channels in a control system which only respond to one master and are 'independent' of the rest of the console.

Inductance
Inductance is usually created by turns of wire with or without an iron core. As the current changes it induces a voltage in the coil which opposes the applied voltage and causes the current to lag behind the applied voltage.
See Alternating current.

Infrared (IR)
Wavelengths below the visible wavelength of light, felt as heat. A typical tungsten lamp outputs around 80 per cent of its energy as infrared, whereas a metal halide discharge lamp only produces 17 per cent infrared which helps towards its greater efficacy.

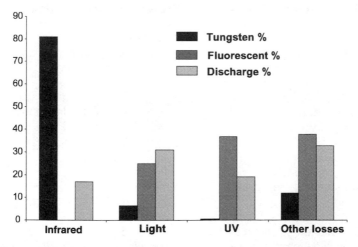

Figure 45 Light source outputs

Inky
A 100 W or 200 W Fresnel luminaire manufactured by Mole Richardson Co.

Instrument (USA)
Name used in the theatre for a lighting fixture (luminaire).

Internal reflector
An integral reflector on the inner rear surface of the envelope of a lamp, usually parabolic or elliptical in shape. It can also be on the front surface of a lamp when it is spherical in shape and used in beam lights.

Inverse square law
The equation which is used to calculate the illumination at a given distance from a source of light, although it is nearly always abbreviated to 'Square law'.
See Square law.

IP Ratings

FIRST NUMBER
Protection against solid objects

0 No protection
1 Protected against solid objects over 50 mm, e.g. accidental touch by hands
2 Protected against solid objects over 12 mm, e.g. fingers
3 Protected against solid objects over 2.5 mm (tools and wires)
4 Protected against solid objects over 1 mm (tools and small wires)
5 Protected against dust – limited ingress (no harmful deposit) permitted

SECOND NUMBER
Protection against liquids

0 No protection
1 Protected against vertically falling drops of water
2 Protected against direct sprays of water up to 15° from the vertical
3 Protected against sprays 60° from the vertical
4 Protected against water sprayed from all directions – limited ingress permitted
5 Protected against low pressure jets of water from all directions

FIRST NUMBER **Protection against solid objects**	**SECOND NUMBER** **Protection against liquids**
6 Totally protected against dust	6 Protected against strong jets of water, e.g. for use on ships' decks – limited ingress permitted
	7 Protected against the effects of immersion between 150 mm and 1 m
	8 Protected against long periods of immersion under pressure

E.g. IP31 – protected against solid objects over 2.5 mm and protected against vertically falling drops of water.

Iris

1) Muscle-operated diaphragm in the eye which controls the amount of light falling on the rear of the eye.
2) A series of adjustable metal plates arranged to give a variable circular aperture. Used in lighting projectors to alter the size of the light beam.
3) Can also be used as a dimmer on a light source when out of the optically focused plane.

J

J-box (USA)
An in-line junction box. The term usually refers to a junction box fitted with Socapex connectors and used to connect an extension cable to the existing head cable of a discharge luminaire.

Jockey boxes (USA)
Metal storage containers on the underside of a truck. Jockey boxes usually store sandbags, cable, and so on.

Junior (USA)
A 2 kW Fresnel spotlight.

Junior stand (USA)
A stand with a 1 1/8″ spigot holder.

Junior stud (USA)
A 1 1/8″ spigot used for larger items of lighting equipment.

K

kVA (Kilovolt Amperes)

With unity power factor, 1 kVA = 1 kW. Whereas wattage is a measure of power consumed in a circuit, kVA gives the total of voltage applied and current flowing. In circuits with low power factors, the kVA will be higher than the wattage. This has important implications when using generators feeding discharge sources, where the ballasts have poor power factors, i.e. the <u>actual current</u> will be greater than the current value derived from the wattage figures of the light sources.

Kelvin (K)

The SI unit of thermodynamic temperature. It uses the same size of degree as the Celsius scale. (Zero K = –273°C.)

The Kelvin colour temperature scale can only be used when measuring a source that emits energy in a continuous spectrum and approximates to a blackbody radiator such as a tungsten filament.

A lamp with a 2700 K colour temperature produces approximately the same spectrum of light as a blackbody at 2700 K. (Most hot objects do not follow Planck's' blackbody radiation law: only perfectly black objects do.) The visible spectrum portion of the blackbody curves is continuous over the visible wavelengths. As an object becomes hotter, the amounts of red energy and blue energy vary in relation to each other. A meter which measured the ratio of the red/blue balance would give a reasonably close approximation to blackbody temperatures. In fact, the older style of colour temperature meters made throughout the world generally employed a red and blue filter to measure the relative amounts of each and thus find the corresponding colour temperature.

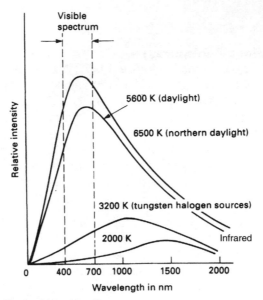

Figure 46 Typical blackbodies

Key light

The principal modelling luminaire, usually a spotlight, but can be any light source. Small fluorescent luminaires are often used where space is at a premium, and although essentially producing a softer light, can give reasonable modelling on the subject. Incident angles to the subject vary from 30° to 45°. Steep key angles may give problems with subjects wearing spectacles.

a) Plan view b) Side view

Figure 47 Key light

Kicker
Generally a hard light source used to provide obvious highlights; usually on the cheeks of male and female subjects.

Kick-out (USA)
The accidental unplugging of a luminaire.

Kilowatt (kW)
Electrical power term for 1000 watts, e.g. 10 A × 100 V, 4.35 A × 230 V.

L

LD
Abbreviation for Lighting Designer or Lighting Director.

Ladder (Theatrical term)
A metal ladder-like structure, suspended from above or mounted to a wall, that provides a position from which to hang luminaires. Ladders are usually used in theatres to position a vertical row of luminaires at the side of the stage. They are constructed from standard 48 mm tubing (barrels).

Lamp
A borosilicate high temperature glass or quartz envelope which contains tungsten filaments or discharge electrodes. The term 'lamp' is often used to describe a luminaire, which is to be avoided as it can cause confusion (colloquial terms include globe, bubble, source).

Lamp bases
See Appendix 9.

Lantern
See Luminaire.

Latest takes precedence (LTP)
On a lighting control system, where the last selected level for a particular channel will win. E.g. if '7' then '5' are selected for a particular channel, '5' will win.
See also Highest takes precedence

Leko (USA)
A slang term to describe ellipsoidal spotlights.

Life
Usually refers to the manufacturer's rated life in hours of a lamp at its normal voltage and is based on the average life of a number of lamps which have been tested. Life in tungsten

lamps will be dictated by the rate at which the filament burns. The lower the colour temperature the longer the life. Life is also dependent upon the internal pressure in the lamp envelope. Halogen fillings also enhance life but their greatest contribution to the light output is the maintenance of colour temperature and lumen output.

Light centre length (LCL)
The distance from the centre of a tungsten filament to a standard point at the base of the lamp. It also describes the distance from the centre of the arc to the base, in single-ended discharge lamps.

Light meter
A device for measuring reflected or incident light. Many modern meters also measure the colour of the source.
See Reflected light, Illuminance and Colour meter.

Light-balancing (LB) scale
Scale used on Minolta colour meters.

Lighting balance
See Balance.

Lighting batten
A theatre barrel assembly with integral power cables and sockets for attaching luminaires. Will have a specified maximum working load (SWL) which dictates how many luminaires and cables can be rigged.

Lighting control console
A unit which contains the controls for adjusting the channel levels and thus the dimmer outputs, 'group channel' control, memory control, playback system and special effects. They will also control remote functions on motorized luminaires, such as VariLites.

Lighting Designer (Director)
The person who creates and implements the lighting design for a production.

Lighting grid
1) In <u>television</u> a structure mounted at high level above the operational area, usually made from steel or aluminium or a combination of the two, for the purposes of suspending luminaires and ancillary lighting equipment. The size of the metal tubes for barrel construction derives from the original steel gas pipes of 1 1/2″ bore (outside diameter 48 mm), used for the original stage gas lighting in theatres.
2) In <u>theatre</u>, it is the framework above the stage in a close gridiron formation to allow operators access for positioning luminaires and scenery.

Figure 48 TV studio lighting grid

Lighting plot
The instructions and drawings of the various lighting set-ups for a production, used by the LD and electricians *(sometimes simply known as the 'Plot')*.

Lighting ratio
The ratio of the light level on the key light side to the light level on the filled side.

Limbo
Describes a state of lighting where the background details are suppressed. In television this is usually created by 'blackness', whereas the film industry tends to use a white background.

Linnebach projector
A lighting unit, basically a box without a lens, which contains a small point source of illumination to project soft diffused images of cut-outs or glass slides.

Load
Usually refers to the total amount of amperes or kilowatts placed on an electrical circuit.

Louvres
1) Thin black metallic strips located on a luminaire to reduce spill light. *See Egg-crate.*
2) When fitted in front of a luminaire may also be adjustable at various angles to provide dimming without colour change. Very similar to the action of a Venetian blind. *See Shutters.*

Low boy (USA)
A very short stand.
See Turtle stand.

Low key
Describes a scene containing mostly dark tones with large

areas of shadow and is often used to create a dramatic mood.

Lug

A heavy-duty connector, similar to a miniature G clamp as used by carpenters, for attaching large feeder cables to bus bars. The original Technicolor lugs are still used in the film industry. Also called sister lugs.

Lumen

The lumen is the unit of 'luminous flux' and is defined as the amount of light which falls on one square metre of a surface at a <u>constant</u> distance of one metre from a source of one candela.
See Foot-candle.

Lumens per watt

The light output in lumens produced by a source for each watt of electrical power supplied to the source. Known as efficacy.

Luminaire

A general term for a complete lighting unit. It includes the housing, the reflector, lens and lamps. (Colloquially: light, lantern, fixture, unit, instrument, fitting.)

Luminaire safety

See Appendix 1.

Luminance

The light emitted from a unit area in a specific direction is called 'luminance' and is measured in candelas per square centimetre, which indicates how bright an object actually appears, and this may be an illuminated area or the area of a source of light. The luminance of a surface determines how bright that surface actually appears. One candela per square centimetre equals 2920 foot-Lamberts.
See Foot-Lambert.

The following table gives the values of luminance for typical sources:

Note: *For practical purposes the following figures are given in candelas/m^2 as candelas/cm^2 is a very small unit.*

Source	Luminance (in cd/m^2)
Sun	1600×10^6
Crater of carbon arc	200×10^6
Tungsten lamp (100 W clear)	6.5×10^6
Tungsten lamp (100 W pearl)	8×10^4
High pressure Mercury lamp (400 W clear)	120×10^4
Fluorescent lamp (80 W)	0.9×10^4
Low pressure Sodium lamp (140 W clear)	8×10^4
Clear blue sky	0.4×10^4
White paper (reflection factor 80 per cent) illumination 400 lux	100
Grey paper (reflection factor 40 per cent) illumination 400 lux	50
Black paper (reflection factor 4 per cent) illumination 400 lux	5

Luminous flux

Measures the total light output of a source and its unit of measurement is the lumen. However, luminaires focus the light sources in a specific direction and light emitted in a specific direction is measured in candelas, and is called the luminous intensity.

Luminous intensity

A measure of the energy from a light source emitted in a particular direction. It is measured in candelas.

Lux

The unit of illuminance (illumination). It is the unit of measurement for the incident light arriving at a surface. The old measuring system used foot-candles. (One foot-candle equals 10.76 lux.) *See Foot-candle.*

M

MCB (Miniature Circuit Breaker)

Usually provided to carry and break normal load currents from 5 A up to 100 A and under fault conditions automatically breaking abnormal currents such as those caused by a short circuit. They have fault current ratings up to 9 kA.

MCCB (Moulded Case Circuit Breaker)

These are usually used to carry and break normal load currents from 100 A upwards and are invariably used on the main bus bar distribution system within the power switch-rooms. They have much higher fault current ratings than MCBs.

MIDI (Musical Instrument Digital Interface)

A communication protocol used to link control consoles for both lighting and automated luminaire systems.

MR-16

A small projector lamp with a self-contained reflector.

M.S.R. (Medium Source Rare earth)

Single ended discharge lamp with correlated colour temperature of 5600 K.

MT-2

A colour-correction gel used on carbon arc lights with a Y-1 gel to correct the colour temperature of a white flame arc to 3200 K.

MacBeth

A blue dyed glass filter used on some open faced luminaires which converts tungsten sources to daylight.

Mafer clamp
All purpose grip clamp which can utilize different mounting attachments.

Master/Group master
Usually refers to a lighting control system fader which overrides, by electrical means, a group of individual faders.

Matte
An opaque shape used in front of a camera lens

Matte process
A shape derived on film from subjects in front of a dense, coloured background (usually blue). This image is subsequently used as a matte in the optical printing process to allow two images to be combined. With the advent of computers, the image manipulation is carried out electronically.

Matth pole (USA)
A pole that braces against two opposite walls to provide a structure from which to hang a lightweight luminaire. Poles originally manufactured by Matthews as grip equipment (also called polecat, barricuda).

Maxibrute
A large rectangular luminaire fitted with either nine 1000 W PARs or twenty-four 1000 W PARs, capable of being switched in segments to provide variable light output. Often used with Full Blue filter to provide fill light when shooting in daylight on location.

Maximum overall length (MOL)
The overall physical length of a lamp including all electrical contacts.

Meat axe (USA)
An arm mounted to the pipe of a catwalk or to the basket of

a boom platform that provides a method of placing a flag in front of a luminaire.

Meltric (USA)
A five-pin, heavy-duty connector used in some power distribution systems.

Memory
1) In human beings, the information stored in the brain as knowledge or pictures and used to process sensory stimulation.
2) The term used to denote electronically recorded information which contains the lighting set-ups.

Memory effect
Usually found in nickel-cadmium (Ni-Cad) batteries. Caused by insufficient discharge, where the battery upon recharge will only accept a limited level. In practice, shows as poor battery life.

Mickey (USA)
A 1 kW open face luminaire manufactured by Mole Richardson.

Midget (USA)
A 200 W wide-beam Fresnel luminaire manufactured by Mole Richardson.

Mini
A 100 W or 200 W Fresnel luminaire manufactured by Mole Richardson, or a miniature softlight manufactured by LTM.

Minibrute
A rectangular luminaire fitted with either six 650 W PARs or nine 650 W PARs, capable of being switched in segments to provide variable light output. Often used with Full Blue filter to provide fill light when shooting in daylight on location.

Minus green gel
A magenta gel used to take the green out of fluorescent light.

Mired
A problem that exists with filters is the fact that they cause a definite change and are dependent upon the light source for the resultant colour output. A blue filter placed in front of a 3200 K lamp would create much less change than if it were used to filter a discharge source at 5600 K. As this is the case, it is not useful to label a filter as a 2000 K correction filter. Luckily there is a way around the problem and this is by using 'micro reciprocal degrees'. Suffice it to say that a filter will cause a constant shift in the reciprocal value of the colour temperature of the source.

To make the maths easier, the reciprocal value is multiplied by one million, and thus **mired** *stands for 'MIcro REciprocal Degrees'*. Thus a colour temperature of 2000 K is equivalent to 500 mireds and 4000 K equates to 250 mireds. A filter which changed the light from the source from 2000 K to 4000 K would thus produce a change of −250 mireds. This filter can be designed so that it always produces the change of −250 mireds, irrespective of the original source. Note that filters which decrease the colour temperature of sources have positive values, but filters which increase the colour temperature have minus mired shifts.

By looking at some examples it is possible to see how this system is used in practice.

1) 3200 K Source 312
 Filter value −72
 Final mired value 240

$$\text{Therefore Colour Temp.} = \frac{1 \times 10^6}{240} = \textbf{4167 K}$$

2) 4000 K Source 250
 Filter value $-\underline{72}$
 Final mired value 178

 Therefore Colour Temp. $= \dfrac{1 \times 10^6}{178} = \mathbf{5600\ K}$

Note that although the same filter has been used in examples 1) and 2), the Colour Temperature change in 1) is **967 K** and in 2) **1600 K**.

Mirror ball
A motor-driven ball with its surface covered in small mirrors. When rotated, with spotlights shining on to it, it produces moving points of light.

Modelling light
The term is used to describe any luminaire, generally a hard source, that reveals the depth, shade and texture of subjects.

MoleFay (USA)
A lighting unit consisting of a number of 650 W FAY lamps manufactured by Mole Richardson.

Monopole
A telescopic suspension unit used to suspend one luminaire. Its length is adjusted by internal wire ropes on winding drums at the top of the unit. The drum can be wound by manual means, air guns or electric motors. Modern safety regulations require that two independent wire ropes are used for internal suspension and that the unit is fitted with overload and slack wire sensors, together with sensors for its travel limits.

Motorized luminaires
In recent years the number of motorized effects luminaires has grown very rapidly to allow a multiplicity of projected images and colours. Units tend to be of two types – the light beam is modulated by a moving mirror with the luminaire

stationary, or, the luminaire moves to create motion. A typical unit, usually powered by a small discharge lamp, will provide the following control functions:

intensity	cyan dichroic	rotating gobo
focus	magenta dichroic	pan/tilt
iris	yellow dichroic	speed control
colour	gobo	reset

To use all these functions, specialized lighting consoles have evolved to encompass dimming control of tungsten sources and the motorized effects used by these luminaires.

Motorized luminaires have also been introduced into the TV industry but tend to be limited in numbers. Control is usually provided for pan, tilt, focus and control of the barndoor flaps and their rotation.

Mountain leg
One leg of a three-legged stand that extends to allow the stand to remain upright on uneven ground.

Move fade
A fade from one lighting set-up to another where *only those channels with a new intensity* change; the other channels remaining static. Several 'Move' fades can occur at the same time.
See Cross fade.

Multi-line spectrum
The spectral energy distribution graph of a discharge source such as a H.M.I. luminaire. Instead of a continuous line across the colour spectrum, the colour makeup is created by numerous single spikes. Each chemical element has a unique set of wavelengths and thus bright lines within its spectrum, and these can be used just like 'fingerprints'. With the advent of electricity, research was carried out on the effect of voltage when applied to gases. During the latter part

of the 19th century many different gases were studied and their element lines plotted, and it was discovered that some gases have thousands of lines and some have very few. Sodium in particular has only two lines in the yellow part of the spectrum, so close together they appear as one and this is the characteristic of many street lights that are in use today. Neon, on the other hand, has very strong lines in the red and orange.

Discharge sources utilize several chemical elements to provide the necessary energy spikes to give good colour rendition.

Multiplex
Control signals passed in serial digital format down a pair of screened wires. The most normal form is DMX 512 and is used to control dimmers and motorized luminaires.

Munsell values
One of the first attempts to define colour precisely was by an American called Albert Munsell in 1915, and his three-dimensional colour system is still in use today. The Munsell system enables three qualities to be quantified and these are:

hue – describes the basic colour such as red or blue;

value (or brightness) – refers to how light or dark the colour appears (it is a measure of the amount of reflected light);

chroma (or saturation) – refers to the intensity of colour; as a colour moves away from white it becomes more and more saturated.

However, the Munsell system is only as good as the illumination it is viewed in. We have all come across the situation where the piece of material that we're buying in the shop or the suit that we have selected looks much better when we go to the doorway of the shop and examine it under daylight. We are also aware of how bad our skin looks under

sodium street lighting. Coloured objects reflect light, the problem is that they don't reflect the entire spectrum of the light that falls on them or the light that falls on them is deficient in some way.

Musco light

A very powerful mobile lighting truck which contains a generator and a telescopic arm, capable of a height of 33 m. There are sixteen 6 kW luminaires attached which can all be remotely controlled from ground level for adjustment on the lit area.

N

ND
See Neutral-density filter.

NEC (USA)
National Electrical Code – the American version of the UK Electrical Regulations.

Nanometre (nm)
A unit of metric measurement equal to one billionth of a metre, which is used to measure light wavelengths.

Net
A black honeycomb netting material sewn onto a rod frame that is used to reduce the intensity of part or all of a light's beam.

Neutral-density filter
A filter which attenuates the light passing through it without affecting the colour of that light.

Ni-cad batteries (Nickel Cadmium)
Ni-cad batteries are a great advance over the old, heavy lead acid and the small zinc acid batteries used for equipment. They have the advantage of being easy to handle, robust and accept very fast charges using specialized equipment. Ni-cad batteries retain their capacity better if the discharge cycle is completed to the point where the knee of the discharge curve is reached. To discharge batteries beyond this point may push some cells into deep discharge from which they may not recover, thus potentially rendering the battery useless. Overcharging a battery is not good practice and if a battery has been left charged for some time or is partially discharged, <u>it should be discharged fully</u> before it is recharged. Batteries charged slower than 1/10th of the Ampere/hour rating of the battery (trickle charge) can be left

on charge for long periods without damage to the battery. Ni-cad batteries do drain slowly when left charged (approximately 10 per cent per week). Battery manufacturers recommend that Ni-cad batteries should be stored in a discharged state. However, they may be left on trickle charge for 'stand-by' use for urgent work.

In order to check the capacity of a 30 V battery, a typical procedure is as follows:

1) Discharge the battery to 25 V using a Battery Capacity Meter.
2) Recharge the battery.
3) Reconnect the battery to the Battery Capacity Meter.
4) Adjust the discharge voltage to 27 V.
5) Switch the discharge current to 8.5 A.
6) Zero the digital timer and press the red 'discharge' button.
7) When the battery has discharged to 27 V the timer will register the discharge time.

If the discharge time is in excess of 20 minutes, the capacity of the battery is satisfactory. If the discharge time is less than 20 minutes, the battery should be recharged using a charger in the recovery mode. After the charging is complete repeat the test procedure. Any battery that discharges in less than 20 minutes for a second time should be referred to the appropriate maintenance department or supplier for remedial action.

A typical charger of the fast type will charge a fully discharged 7 Ah battery in approximately 2 hours, or a 4 Ah battery in approximately 1 hour and then drop to a trickle charge state.

There is no common connector standard for many of the proprietary battery packs and belts used in the lighting industry; therefore, it is important to have the necessary adapter leads for the various items of equipment.

Nine-light

A luminaire comprising nine PAR lamps used on exterior lighting.

Nit

The unit of luminance, which is one candela per square metre of surface radiation. It is therefore the measure of the <u>brightness</u> of a surface.

See Foot-Lambert.

Non dim

Describes the circuit which replaces the normal dimmer function, where the circuit is switched 'on' or 'off' <u>only</u>, either by a switch or relay system.

Nook light

A small lightweight open face luminaire using a double-ended lamp and a V-shaped reflector.

O

Objective lens
See Projection lens.

Offset
A piece of grip hardware used to hang a luminaire out to the side of a floor stand.

Off-stage
Areas that are out of the eyeline of an audience.

Ohm (Ω)
The unit of electrical resistance. One volt applied to a resistance of one ohm will create a current of one ampere.

On-stage
In view of the audience.

Opal
A popular, thin diffusion.

Opaque
Absorbance of electro-magnetic radiation at specific wavelengths, generally refers to the fact that light is not transmitted.

Open faced luminaire
Describes luminaires with no lens system, such as the 'Redhead' and 'Blonde'.
See Focusing reflector light.

Overcurrent device
A circuit breaker or fuse.

Overhead set
A large frame with one of several types of material stretched across it, including a solid, single net, double net, silk, or Griffolyn.

P

PAR

A lamp with an integral parabolic reflector, similar to a car headlight. PAR lamps are available in a wide variety of physical sizes with differing front lenses and power outputs.

Because the lamp is completely sealed, it can be run at a high pressure and consequently provides a high efficiency. The most popular lamp is the PAR 64 and, as with all PAR lamps, the number is the diameter expressed in eighths of an inch, therefore a PAR 64 is 8″ in diameter or 204 mm. The beam is usually oval and typical beam angles are (9°H 12°W) (10°H 14°W) (11°H 24°W) (21°H 57°W) (70°H 70°W) for 240 V lamps. Manufacturers also make a lamp with a clear glass for use with separate lenses. Beam angles and efficiency vary with voltage when comparing 240 V and 120 V lamps because of the compact filament in 120 V lamps. The most common application of this type of lamp is the Parcan, generally used for its high light output, small size, low cost and light weight.

The majority of PAR lamps in use are of the tungsten type but there is a rapidly increasing use of discharge sources mounted in PAR housings *(see Figure 49b).*

PCB (Printed Circuit Board)

Individual boards are supplied with all components mounted on them and will be produced for a specific purpose, e.g. a PCB for dimmer control circuits.

Pan

Term describing the horizontal movement, about a point, of luminaires or equipment.

Pancake

The thinnest of the apple box range used for mounting equipment at a very low level.

Pantograph

A mechanical cross-armed device for varying the height of luminaires or other fittings. It is generally spring balanced but can be operated by a motor- or manually-driven gear system and it can be mounted on roller trolleys, allowing it to move along long single trackways. This gives extremely good height flexibility and, when the trackways are positioned as close to each other as possible, also offers a very good coverage over the acting area. Generally, the system uses spring pantographs where the height can be easily adjusted.

Horizontal movement is accomplished by dragging or pushing the pantograph top trolley unit along the trackway. The major drawback of the system is that special safety precautions have to be taken when changing luminaires on spring pantographs. A modern advance, favoured by some large broadcasting organizations, is to use motorized pantographs where the height is adjusted by motor-driven wire ropes and the horizontal movement provided by a motor drive onto the trackway.

Paper method (USA)

A method of calculating an approximation of the current of luminaires by dividing the wattage by 100. (*Note: Only useful with 120 V systems.*)

Parabolic reflector

A reflector shaped like a parabola, giving it a focal point from which the majority of the light rays will be reflected outward in a parallel beam. As can be seen from *Figure 49 a)*, not all the light is returned from the reflector, some light will escape from the optical system.
See Beam light.

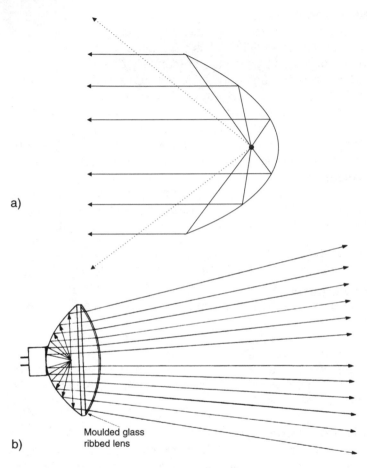

Figure 49 a) Parabolic reflector; b) PAR lamp

Parallel circuit

Connection of two or more devices or loads so that the current flowing through each one follows a separate path. *See Series circuit.*

Figure 50 Parallel circuit

Parcan

A simple luminaire, basically a metal tube, with a PAR lamp mounted in it. The type of lamp determines the beam spread. One great advantage of Parcans is the very high light output.

Party gel (USA)

Coloured gels, also called effects gel or theatrical gel.

Patch panel

A system rather like an old telephone operator's inter-connection system (switchboard) to connect low voltage circuits or high voltage circuits. Known as 'Hard patching'.

Patching

A term describing the routing between channels on lighting consoles and dimming systems. This is now usually accomplished by software – known as 'Soft patching'. Most modern lighting consoles are capable of quite sophisticated patching arrangements.

Peppers (USA)

A line of relatively compact tungsten luminaires manufactured by LTM in sizes of 100 W, 200 W, 300 W, 420 W, 500 W, 660 W, 1000 W, and 2 kW.

Phantom load

See Ghost load.

Phase

1) An energized single conductor.
2) The positioning of an a.c. cycle in time, relative to the other two phases. Most electrical services are either single phase or three phase.

See Alternating current and Wye-connected system.

Photoflood

A lamp that has a colour temperature of 3400 K. These lamps, which are similar in size to household lamps, have over-driven filaments to achieve the high colour temperature. Hence they have very short operating lives.
See Filament.

Photopic curve

Not every individual has the same sensitivity to light, therefore the CIE adopted an internationally agreed response, which is called the CIE standard observer. This gives the standard sensitivity for the eye for wavelengths from 380 nm to 760 nm. The peak sensitivity is at 555 nm, whereas the sensitivity at 400 nm is about 1/1000th of the highest level. In practice, this means that one watt of radiation in the green part of the spectrum has an effect 1000 times greater than one watt of radiation at the blue end of the spectrum. *(Figure 51)*
See Tri-stimulus.

Piano board (USA)

Originally, a portable dimmer switchboard or road board. This term has come to be used for many types of portable dimmer switchboards.

Pigeon plate

A small metal plate attached, generally, to apple boxes for supporting small luminaires.

PHOTOPIC CURVE (Y)

Figure 51 Photopic curve

Pipe clamp (USA)
See Hook clamp.

Pixel
A picture element which is the smallest element of a CCD array. The definition is governed by the number of 'pixels per area'; the higher the amount the better the resolution. A CCD with around 500 000 pixels is of a fairly low order and some CCDs used for high quality colour photography have well in excess of 1 million pixels.

Plano-convex lens
A lens which has one flat side and one convex side.

Plano-convex spotlight (PC spot)
A luminaire that gives a reasonably even beam with a very sharp edge.

The PC uses a plano-convex lens and circular reflector and is similar to the Fresnel in construction and performance. It is used mainly in the theatre because it has a well defined soft

edge to the beam and does not produce spill light that would otherwise fall onto parts of the set or backing and cause problems. Two disadvantages are that a project of the filament tends to be apparent in full spot, and between flood and spot there is a dark hole in the centre of the beam. Some manufacturers provide a diffusion on the rear surface of the lens to reduce both problems.

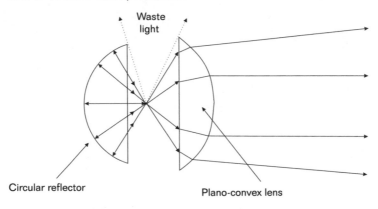

Figure 52 Plano-convex spotlight

Plate dimmer (USA)
A resistance-type dimmer commonly used with d.c. circuits.

Playback
That part of a lighting control system where the lighting memories and/or other lighting states are combined and controlled by output master faders or switches.

Plugging box (USA)
A distribution box. May also refer more generally to any outlet box.

Plus green gel
A filter used to add green to the light output of normal lamps to match their colour to that of fluorescent lamps.

Pocket (USA)
Outlets for stage circuits, often located under a protective trapdoor; for example, floor pockets, wall pockets, and fly pockets.

Polarizer
Natural light consists of vibrations of energy at right angles to the direction of propagation. Polarization arises from reflection on surfaces and is very troublesome on glass, shiny surfaces and water. A polarizing filter removes some of the planes of polarization and allows the subject to be seen clearly. Two polarizing filters, one twisted at 90° to the other, prevent any light passing through. At any point between 0° and 90° a degree of dimming will occur. Polarizing filters fitted to a camera will enhance cloud formations by darkening the blue of the sky.

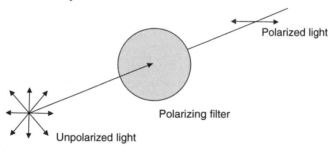

Figure 53 Polarizing filters

Polarity
The orientation of the positive and negative wires of a d.c. circuit or the phase and neutral wires of a.c. circuits.

Polecat
Lighting support system consisting of sprung metal tubes capable of extension onto which luminaires can be mounted. Used between two surfaces, floor and ceiling or two walls. Also called *pogo stick* and *Matth pole*.

Pole operation (colloq. Pole op)

The control of electrical and mechanical functions on lumin-aires and suspension equipment by means of a long metal pole. The end of the pole is fitted with either a hook or loop.

Power

The total amount of work, measured in watts. One watt is equal to one joule per second; one horsepower is equivalent to 746 W.

See Ampere and Volt.

Power assisted systems

Suspension equipment under the direct control of an operator, e.g. winch control motor systems.

Standard motorized barrel units will have the electrical motor drive unit, gearbox, wire rope winding drums and the wire rope diverter pulleys mounted at grid level. The barrel unit, together with its associated lighting power sockets, mounted on an integral trunking system, is suspended from the grid unit by wire ropes *(Figure 54)*. The associated electrical control box can be positioned adjacent to the unit or away from the unit in purpose-made cabinets. *(Figure 55)*

Typical 3 metre Barrel

Single 5 kW socket 9-pin cyc sockets Single 5 kW socket DMX in & out Single 5 kW socket

Figure 54 Standard hoist

A self-climbing barrel winch has all its main drive system mounted integral to the unit immediately above the suspension barrel. The combined unit is suspended from the grid by wire ropes. The total weight imposed on the grid of either unit is the same. Because the self climber has to lift its own weight, plus the attached load, it has to be provided with a higher rated motor than the equivalent standard unit. Other power-assisted systems are motorized monopoles and pantographs.

Power factor

In a.c., the ratio of the actual or effective power in watts to the apparent power in volt-amperes, expressed as a percentage. Inductive loads cause the current to lag behind the voltage, resulting in a power factor of less than 1 (unity). Capacitive loads cause the current to lead the

Figure 55 Self-climbing hoist

voltage, also resulting in low power factors. Most solid-state discharge ballasts have a capacitive input and therefore require special power factor correction circuits, whereas choke ballasts can be corrected fairly simply by the addition of capacitors.

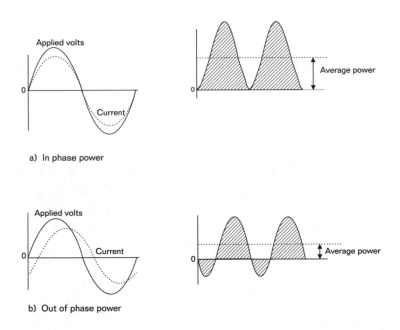

a) In phase power

b) Out of phase power

Figure 56 Power factor

Practical lamp

A luminaire or any fixture that is shown in a scene, e.g. a table lamp, that can be effectively switched on and off by an actor. In television, the luminaire will usually be remotely switched from the lighting control console.

Prelight or prerig
To rig and set the lights in advance, as close to the intended lighting scheme as possible. When shooting films, during the course of the production, the grip and electrical crew may form a second crew or bring in a second crew, rigging the sets and lights that are to be used during the following days.

Pre-set
A group of faders on a manual desk which are connected to the dimmers and controlled by a 'master fader'. As there are usually two pre-sets or more on manual lighting control systems it is possible for a lighting plot to be set up in one pre-set without affecting the active pre-set. (*This is known as blind plotting.*)

Primary colours
The primary <u>additive</u> colours are red, green and blue. The primary <u>subtractive</u> colours are cyan, magenta and yellow. When the primary additive colours of light are projected onto a white surface, the area where all three colours overlap should theoretically make white light.
See Additive colour mixing and Subtractive colour mixing.

Prime fixture (USA)
A focusing, open faced luminaire such as a Redhead or Blonde.

Priscilla (USA)
A silver lamé stretched on a frame and used to bounce light.

Profile spot
See Ellipsoidal spotlight.

Projection lens
A lens specially designed to project slides or shapes onto a surface with considerable enlargement of the slide or original material.
See Objective lens.

Proscenium arch (opening)
The surround to a theatre stage area and through which the audience views the performance.

Pup
A colloquial term for a 1 kW spotlight.

Purkinje effect
In 1825, Jan Evangelista Purkinje noticed that at twilight the flowers in his garden apparently changed colours in relation to each other as the illumination changed. As it became darker, red flowers became black, although at this point the green leaves were relatively unaffected. Purkinje had experienced the change from 'cone' vision during daylight to 'rod' vision at night. The 'rod' light receptors, although generally more sensitive than 'cones', have a lower response to light at long wavelengths, thus reds diminish rapidly at dark. The Purkinje effect states that there is a shift of maximum sensitivity towards blue at low light levels.

Putty knife (USA)
Decorators' putty knife which has a 5/8″ spigot fixed to its handle. The knife can be inserted into the slot of a door frame or windowsill and the spigot will support a small luminaire.

Q

Quartz

Crystalline silica which is glass like and used to make envelopes for lamps. It is generally transparent to ultraviolet radiation. When used for lamp construction it is easy to contaminate the surface if handled, thus depositing grease and sweat, etc. on it.

R

RCD (Residual Current Device)
Formerly known as an earth leakage circuit breaker, these devices work on the principle of a balanced phase and neutral current. Any leakage to earth (ground) from either conductor will cause the device to operate. To prevent electric shock the device has to operate rapidly and also be capable of detecting very low currents. A typical RCD is rated at 30 mA with an operating time of 40 milliseconds. It should be noted that if personnel were in contact, simultaneously, with phase and neutral, the RCD will probably be inoperative as current in both conductors is equal.

R.M.S. (Root Mean Square)
The R.M.S. value of the current is a measure of its effectiveness in producing the same heating effect in a resistance as a direct current. It therefore allows for various wave shapes and directly relates to the power in watts.

Radiant flux
The amount of light energy that is given off by an object each second and is measured in 'joules per second' (the physical unit of measurement is known as a watt). A 100 W lamp, therefore, radiates a total of 100 joules of light energy each second. However, a 100 W tungsten lamp only radiates approximately 5 W of visible light, the remainder being radiated as non-visible infrared. To raise the amount of useful watts of light output, it is necessary to compress the energy from the light source into the visible part of the spectrum. As the eye varies in sensitivity with the wavelength of light, it is impractical to use the watt as a measure of the light output. The eye's peak sensitivity is at 555 nm (green), whereas at 400 nm the sensitivity is 1000 times less. Thus, one watt of

radiation in the green part of the spectrum is 1000 times more effective than one watt in the blue. Low pressure sodium lamps emit practically all their light at around 590 nm; as this is very close to the peak sensitivity of the eye, it is highly efficient in terms of the number of lumens per watt. Thus, by concentrating the energy into narrow bands, it may be possible to produce light sources with outputs as high as 160 lumens per watt and, in fact, it is this type of light generation that is employed in modern high energy light sources such as the H.M.I., M.S.R. lamps.

Rag (USA)
The cloth part of an overhead set.

Rain tent
A tent to cover luminaires and electrical equipment in case of precipitation.

Reactance (X)
A measure, in ohms, of the opposition to a.c. due to capacitance (X_C) or inductance (X_L).

Receptacle
An in-line female electrical connector or a socket mounted on a distribution box.

Record
The action of recording (memorizing) a lighting set-up on a control system.

Rectifier
An electrical unit that converts a.c. to d.c.

Redhead
A 800 W open faced luminaire.

Reflectance (reflection factor)

The ratio of the reflected light to the incident light falling on a surface, measured in lumens.

Reflected light (luminance) meter

Luminance meters are used for the measurement of a light source or surface brightness. A normal luminance meter will be calibrated in candelas per square metre and, alternatively, foot-Lamberts. Two types of luminance meter are used:

1) A spot meter where the angle of acceptance can cover very small areas at a distance and also where no light enters the cell outside the angle of acceptance which would give false readings. For average use, an acceptance angle of one degree is acceptable, however, for very accurate luminous measurements on small areas one-third of a degree is possible in some meters. These meters can be extremely useful where the source of light is extremely hot, therefore measurements can be taken at a distance.

2) Photographic meters, either the built-in type, as with most modern 35 mm cameras, or a hand-held meter, measure the reflected light from the scene which is going to reach the film. As the film has a certain sensitivity, either the stop and/or the speed of the shutter have to be adjusted so that the correct quantity of light reaches the emulsion, so that well-exposed pictures are produced. Nowadays, most cameras do everything automatically.

The basis of reflected light measurements is an 18 per cent reflectance value which produces an average brightness standard of measurements for film and TV cameras. Only the amount of light is measured, not the colour of the source, as long as the meter responds faithfully to all visible wavelengths. A red card that reflects 18 per cent of the light striking it or a green card with the

same reflectance, will appear to be equal as far as a camera is concerned because no account has been taken of the colour involved. It is possible to be caught out when taking pictures of snow scenes or pictures in very dark areas when the average brightness cannot equate the scenic values very accurately to the 18 per cent reflectance.

See Spot meter.

Reflector
The component in luminaires that focuses the light rays towards the lens. In a Fresnel it will be a spherical reflector whereas PAR lamps use parabolic reflectors. Effects projectors (Leko) generally use ellipsoidal reflectors.

Reflector boards
Silver-covered boards typically used to bounce light, usually sunlight. Also called shiny boards.

Remainder dim
A lighting console instruction which maintains the levels of selected channels, while forcing all other active channels to zero.

Rembrandt lighting
Lighting style emphasizing the subject by strong modelling of light and shadow. This style is reminiscent of Rembrandt's paintings, hence its name. It is created by having the key light at a horizontal angle of 45° with the vertical angle approximately the same which creates an obvious triangular patch of light on the shadow side of the face.

Remote
A method of controlling the lighting from a position away from the main control system.

Resistance (Ω)

A measure, in ohms, of the opposition to current flow in a conductor or device. In d.c., volts ÷ amperes = ohms. For a.c., *see Impedance*.

Rheostat

A resistance dimmer to control the voltage applied to a lamp. Also used to control the speed of motors.

Rig

1) Any assembly designed to support luminaires, cabling, dimmers and effects units, etc.
2) To set up scenery equipment and lighting.

Riggers control

A remote portable hand-held control unit for controlling either luminaires or winch systems.

Rigging (USA)

Collective term for suspension equipment.

Rigging bible (USA)

A set of circuit diagrams showing the power layout of a studio's sound stages.

Rigging gaffer (USA)

The gaffer in charge of designing and installing the cabling and electrical distribution for a large set.

Rim light

A backlight that makes a rim around the head and shoulders of the subject from the perspective of the camera, enhancing the separation from the background.

Rise time

In an electronic circuit the time taken for the current to rise from 10 per cent of its amplitude to 90 per cent of maximum. The rate of change of current influences the amount of generated voltage in an inductive circuit. The rate of change

of current in a falling waveform also affects the generated voltage.

Riser

1) An extension tube to add height to a lighting stand.
2) A wooden platform used to raise the set, luminaires or the camera.

Risers

The flat surfaces on the Fresnel lens rings that form the divisions between segments.

Ritter fan (USA)

A large effects fan used to blow snow and rain; also to give the appearance of wind or speed.

S

SCR (Silicon Controlled Rectifier)
A solid-state current switching device, used in dimmers for lighting systems. It comes from the <u>thyristor</u> family.

SPD
Spectral power distribution.

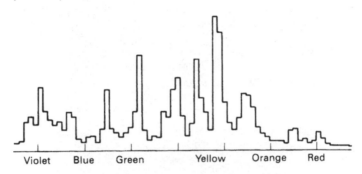

Figure 57 Spectral distribution of a discharge source

SWL
The safe working load of a piece of lifting equipment, usually quoted in pounds or kilograms.

Safety (USA)
A safety bond, wire, chain or rope looped around the yoke of a luminaire to prevent it from falling should it come loose from its fixing point.

Safety bond (also Safety chain)
A short length of wire rope or chain formed into a loop around a suspension point, to act as a secondary means of suspension in the event of failure of the primary system. With wire rope safety bonds, European regulations require that the bond should not allow a fall of more than 300 mm.

Figure 58 Safety bond

Safety instructions
See Appendix 1.

Sandbag
A sand-filled bag used to stabilize stands and equipment by adding dead weight or counterweight.

Saturated rig
A lighting installation where luminaires are installed in sufficient numbers to cover the total acting area without rigging and de-rigging.

Saturation
A term used to describe the density of a colour between the

pure colour concerned and white, i.e. a deep red or pink.

Scaffold platforms (USA: Parallels)

Scaffold platforms, as used by builders, are quite frequently used as mobile lighting towers. They are quick and easy to assemble as they come in pre-formed sections and, if used properly, can be safe. It is essential that the manufacturer's recommendations are followed with regard to overall height and the use of out-riggers for stability.

When using lighting equipment on the platform, it is essential to attach this firmly to the rails and provide safety bonds. On outside locations it is important to take account of the force of the wind blowing on a tower. Any power cables should be tied to the uprights on the platform, leaving plenty of slack to manoeuvre the light. The tower must be provided with proper earth connections.

Scene machine (USA)

A lighting unit that projects an image on a screen, usually from the back. The image can be made to move by scrolling through the machine or to rotate by using adjustable-speed motors. Scene machines are often used to create moving clouds across the cyclorama in theatrical productions. Known as back projection unit in the UK.

Scissor clamp

A device that provides a means of hanging luminaires from a false ceiling, such as those found in many modern commercial buildings.

Scissor lift

A self-propelled, battery powered hydraulic lift. With a lifting capacity of between 300 kg and 600 kg and capable of heights between 6 m and 12 m. Normally used by the building industry, they have been adapted for use as mobile lighting and camera platforms.

Scissors arc

A special carbon arc device used to create a lightning effect. The carbons are touched together by a flexible drive device which is actuated in a similar manner to grass shears. This has been superseded by lightning effects generally produced by xenon tubes driven from electronic generators.

Scoop

A simple elliptical-shaped floodlight usually fitted with a large GLS lamp giving a soft light output. Owing to the type of lamp used, is prone to 'lamp sing' when used with thyristor dimmers.

Scrim

A scrim usually consists of wire mesh placed in front of a luminaire. The size of holes and thickness of wire determine the amount of light that will pass through the mesh. They are generally available as single and double scrims, either half or full, so that some or all of the beam can be attenuated. Scrims can also consist of a piece of diffuser such as a frosted filter. They will reduce the lighting level and additionally produce softer shadows.

Single scrim Double scrim

Half single Half double

Figure 59 Scrims

Sealed beam

A lamp with an integral reflector and lens.
See PAR.

Secondary colours

Those colours produced by mixing either two additive primary colours or two subtractive primary colours.

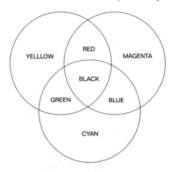

Figure 60 Subtractive colour mixing

Senior (USA)

A 5 kW incandescent Fresnel luminaire manufactured by Mole Richardson Co.

Series circuit

Connection of two or more devices or loads in tandem so that the current flowing through one also flows through all the others.
See Parallel circuit.

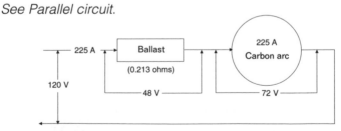

Figure 61 Series circuit

Service (Electrical service)

This term refers to the types of circuits installed, for example, single-phase, three-phase.

Service entrance

The main switchboard into which the power lines running to a building terminate.

Set

Scenery constructed for lighting and the shooting of scenes for film and television.

Shock

The nervous sensation imparted to a body by the passage of an electric current. The severity of shock is dependent upon the current flowing, the path through the body and the time for which the current flows. Death is caused by current passing through the heart causing irregular muscular spasms (fibrillation) and preventing its normal beating pattern.

Effect of current

Current	Effect on body
1 mA or less	No sensation
>5 mA	Painful shock
>15 mA	Muscle contractions causing inability to release hand from circuit
>30 mA	Breathing difficult, possibly unconsciousness
50 mA–100 mA	Possible ventricular fibrillation of the heart
100 mA–200 mA	Certain ventricular fibrillation. Death is possible
>200 mA	Severe burns and muscular contractions. Death is likely through the heart stopping.

See RCD.

Short circuit

Unwanted current flow caused by low impedance between conductors. Usually controlled by fuses or circuit breakers.

Show card

Thick card stock, usually white on one side and black on the other, used to bounce light.

Shutter

1) Pieces of thin black metal used within effects luminaires to block light. In various configurations they offer a variety of shapes in the projected light beam – as demonstrated in *Figure 62.*

2) In a still camera, focal plane shutters are used to control the film's exposure in conjunction with the aperture of the taking lens. The shutter speed is controlled by (a) the width of the slot, and (b) the speed of traverse across the film. In a motion picture camera, a focal plane shutter is also required, which spins in a circular motion in front of the film. The speed of rotation is usually coupled to the frame rate of the camera (e.g. 24 FPS) and instead of a slot, the shutter is provided with angular gaps. The most simple shutter is a single blade with a 180° opening. 'Butterfly' shutters are also used with either fixed angular or variable gaps.

Figure 62 Luminaire shutter

180° Single blade shutter Butterfly shutter at 120°

Figure 63 Camera shutters

Shutters
Venetian blind type metal slats mounted in front of a luminaire
as a blackout device or dimmer.
See Louvres.

Silk
Originally was voile, a type of very fine silk netting used as the
veil around ladies hats. It is used to soften and cut the
intensity of light and is available in several sizes, from very
small dots and fingers to very large 20 × 20 ft. overheads.
Today, other materials with similar properties are used. Silks
can polarize the light and have to be used with care,
particularly when the cameras are fitted with polarizing filters.
 Plastic brushed silk filters stretch the light beam in one
plane and change the light output of a luminaire according to
the rotation of the filter. Often used to spread the light beam
to give a more even coverage, particularly with open faced
luminaires such as the 'Redhead' or' Blonde'.

Silver bullet (USA)
A 12 kW or 18 kW discharge luminaire manufactured by
Cinemills Corp.

Single purchase
A suspension system for counterweight bars where no
gearing is used. The distance of travel of the counterweight
bucket will be the same as the barrel. *See Double purchase.*

Sister lugs (USA)
See Lug.

Sky-cloth
Scenery used to convey the impression of a open sky.
See Cyclorama.

Sky-pan
A very shallow scoop used in the film industry, which is rather like a metal dustbin lid with a bare lamp in the middle. Used for general fill, using either 2 kW, 5 kW, or 10 kW lamps.

Snoot
A conical metal tube fitted to the front of the luminaire to enable a reduction in beam size.

Snot tape
Sticky adhesive substance used to attach gel to a frame.

Socapex
Multi-wire cable connector used:
1) On discharge source head feeder cables.
2) On multi-core cable for dimmer circuits.

Soft box
A device used to create very soft, diffuse light.

Soft patch
Electronic system on a lighting control desk to allocate dimmers to control channels.

Softlight
A luminaire designed to produce virtually shadowless light and is generally used to control contrast.
 The ultimate softlight is the illumination from the sky where it is so large in relation to humans that no shadows are obvious. However, there is no such thing as a <u>small</u> softlight.

The larger the source the softer the shadow, so the design of a softlight is always a compromise between the largest source that can be achieved and the size that can be tolerated in practice. Softlights are used as a fill light to lift the shadow areas created by the key light to an acceptable level for the film stock or television camera. It is desirable to achieve this without creating more shadows on the subject. The main disadvantage is light spilling onto backings or cycloramas and this can be partly controlled by an egg crate placed in the front of the luminaire. The term 'soft' or 'hard' is often misused and does not necessarily describe the quality of light.

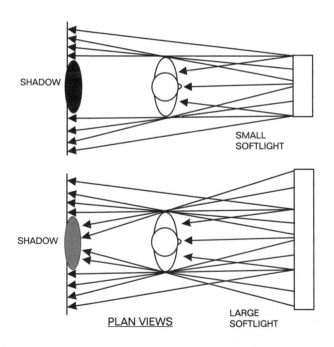

Figure 64 Softlight comparison

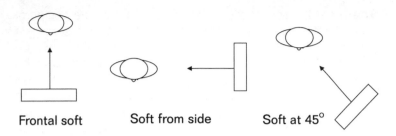

Frontal soft **Soft from side** **Soft at 45°**

Figure 65 Softlight applications

'Soft' or 'hard' is a relative term. For instance, a softlight can give reasonably hard shadows, whereas a larger softlight positioned at the same distance will produce a softer shadow. Conversely, a Fresnel lens luminaire with a brushed silk diffuser fitted can give quite a soft result when used close to the subject.

It must be remembered that both 'hard' and 'soft' light have the same physical properties. 'Hard' light consists of light rays going in straight lines from a very small source to the subject, whereas 'soft' light consists of the same light rays emerging from a larger source area going to the subject in straight lines from a variety of angles. It will have been noted above that as the light rays become more parallel to each other, so the quality of the shadow becomes more 'hard'.

An important factor in the use of softlights, which is often forgotten, is that they have two planes of illumination, the horizontal and vertical. If softness tests are done with a 'projected cross' system it will be found that, as the width of the softlight becomes greater, so the vertical shadows become more diffuse. When the height of the softlight is increased the horizontal shadows become more diffuse. Obviously, there is a finite size to softlights, but the most effective for many subjects are those that are reasonably wide in relation to their height.

Solid
A black 'rag' stretched on a frame and used to cut light.

Sound stage
An enclosed area with smooth level floors and a high roof with lighting grid. It is sound proofed by having thick walls and special door arrangements. In film, used for single camera coverage of sets and action. Television studios, by definition, are sound stages, the main difference being that several cameras will cover the action. This requires multiple sets and consequently bigger lighting rigs.

Space-light
A large cylinder consisting of a diffuser with an array of lamps inside to give soft ambient illumination.

Sparks
A nickname for a set lighting technician.

Specular
Describes a mirror-like surface. Highly reflective.

Spider box (USA)
An in-line connection box fitted with short bus bars enabling feeder cables with lug terminations to be joined in series.

Spigot
The male member attached to a yoke used for the suspension of the luminaire and also for insertion into a floor stand. Smaller luminaires use 5/8″ spigots and larger ones use a 1 1/8″. Colloq. 'spud'. *See Stud.*

Spill light
Extraneous uncontrolled light from a luminaire. May come from the rings on a Fresnel lens or escape from the aperture between the barndoors and colour frames.

Spot
To focus a luminaire by moving the lamp and/or reflector away from the lens, giving a narrow beam. *See Flood.*

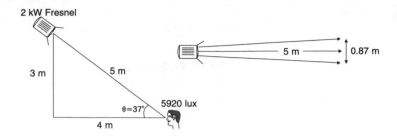

Figure 66 2 kW spotlight in spot position

Spot meter

A type of reflected meter having a very narrow angle of acceptance (1°–20°) used to determine the light value of a specific point on the set. In addition to a standard luminance meter, it is now possible to obtain chromameters where the measurements of the colour tri-stimulus values are made in addition to the candela/m² units or foot-Lamberts. These meters would be used where the light sources are too small to be measured with standard colorimeters, e.g. LEDs and small lamps allowing accurate metering of areas as small as 1.3 mm in diameter. They are also useful to measure light sources when they are operating and very hot.

Spotlight

A luminaire with a focusing system which allows concentration of the light beam, thus giving greater operational control of the light level.

Spotlight coverage

Figure 67 illustrates how an area can be covered by two 5 kW Fresnel spotlights in flood mode. For the same light level, and coverage, 2 kW Fresnels would have to be at 'half spot' and, to cover the same area, nine would be needed. Whereas the two 5 kWs require a total power of 10 kW, the 2 kWs would require 18 kW.

6 metre beam width

3 metre beam width

Figure 67 Beam width coverage

Square law

Most people are aware that the light from a luminaire falls off with distance, and a common misunderstanding is that at double the distance one would expect to get half the light. This is not so, because light is governed by a formula called the *Inverse Square Law* which states that the light falls off as the distance is squared.

$$E = \frac{I}{d^2}$$

where E is luminance in lux, I is luminous intensity of source in candelas and d is distance of source to illuminated surface.

As can be seen from the formula, if the distance changes from 1 m to 2 m the formula gives:

$$E = \frac{I}{1^2} = \frac{I}{1} \ : \ E = \frac{I}{2^2} = \frac{I}{4}$$

Point light sources conform to the inverse square law when calculating illuminance, however when using a larger source area, such as a fluorescent fitting, the inverse square law can only be applied if the distance of the light source from the subject is five times the maximum dimension of the source itself. For example, if the source is 0.5 m across, the inverse square law will be accurate from 2.5 m and above.

If the light reading is taken at a given distance, say 10 m, and has a value of 1000 lux, the light intensity from the luminaire can be determined by simply multiplying the lux reading by the distance squared, i.e.

1000 lux \times 10^2 = 100 000 candelas.

A constant value for the intensity of the luminaire is expressed in candelas.

Example: 1000 W, 3200 K Fresnel spotlight produces:
 74 000 candelas in 'spot' mode
 <u>and</u>
 11 000 candelas in 'flood 'mode.

As can be seen, the act of concentrating the light beam in 'spot' mode produces a brighter source.

Square wave
Alternating current with a square wave shape rapidly switched between positive and negative half cycles. In lighting, it is generated by an electronic ballast which enables discharge sources to be flicker-free.

Squeezer (USA)
A dimmer.

Stage box (USA)

A distribution box with sockets that accept male connectors. Stage boxes are normally referred to by the number of sockets they have: one-hole, two-hole, four-hole, or six-hole boxes.

Stage extension (USA)

A high-current extension cable. It has a male connector at one end and a single or twin at the other.

Stage left/right

The performers left and right as they face the audience.

Staging area

The area on the sound stage or location selected as a temporary place to keep the lighting equipment and technical equipment trolleys.

Stand

A telescopic floor-mounted tripod device which provides a means of adjusting the height of luminaires above floor level. Can be manual lift, or by a geared wind-up system.

Stick-up (USA)

An extremely small, lightweight luminaire that can be taped to the wall.

Stinger (USA)

An extension cable usually fitted with Edison plugs and sockets.

Stirrup

Stirrup-shaped receptacle, generally fitted at the base of extension arms and pantographs, allowing the attachment of luminaires by C clamps.

Stop

An f-stop or a t-stop.
See F-number.

Strain relief
A rope tied to a cable to take the weight and reduce strain on electrical connectors.

Streaks and tips (*Trade name*) (USA)
Cans of hair spray that are useful for darkening reflective surfaces.

Strike
1) To dismantle a set or to take down and put away a piece of equipment.
2) When referring to an arc or a discharge source, to strike the light means *turn it on*.

Strobe light
A light that creates short, bright, regular flashes of light at an adjustable speed. Speeds around 17 Hz are highly dangerous and can induce epileptic fits.

Stud
Term for shaped piece of cylindrical metal which is attached to the yoke (*bail*) and used for mounting luminaires onto stands, etc.
See Spigot.

Studio area
The total floor area contained within the walls of a studio which may not always be used as the acting area, owing to fire lanes, etc.

Sub-master
A controller (usually a linear slider) on a dimmer board that allows manual control of groups, effects, cues, or channels.

Subtractive colour mixing
The removal of light of various wavelengths, by filtering or reflection, e.g. a magenta filter subtracts the green from the

light path, whereas the pigment of yellow paint reflects the red and green components of the incident light but absorbs (<u>subtracts</u>) the blue. To change the colour of a light source for effect or colour correction, some form of coloured filter will be placed in the light path. Colours that are not present in the source cannot be used. The colour of the emerging light from the filter depends upon the spectrum of the incident light striking the filter and on the characteristics of transmission of the filter itself. Both the colour and quantity of light (transmission) emerging from the filter are of importance.

A filter works by subtracting selected portions of the spectrum away from the light source. If the light source starts with the same amounts of red, green and blue, and the filter takes away the green component, the red and blue are left which, when mixed together, give magenta. Thus the magenta filter can also be called a minus green. A yellow filter would allow the red and green portions of the spectrum through, taking away the blue; it can be called a yellow filter or a minus blue. A cyan filter allows the blue and green light through and stops the red portion of the spectrum, therefore a cyan filter is also a minus red.

By removing two colours it is possible to produce the three primary colours used for lighting, i.e. removing the red and blue components leaves green. Removal of red and green gives blue; finally taking away the blue and green leaves red.

As will be realized, the filters given as examples have the ability to subtract *light away from a portion of the visible spectrum*; it will also be obvious that this is a subtractive light process. The amount of light transmitted by any of these filters will be determined by the density of colour of the filter, which is determined by the thickness of the colour layer. By using combinations of the basic magenta, yellow and cyan filters, which are often used in photographic processes, in various thicknesses, almost any colour can be produced. The use of yellow, cyan and magenta filters is widespread in

motorized luminaires such as those made by High End Systems and VariLite.

Desired effect	Filters required
White	None
Black	*Yellow, cyan, magenta
Red	Yellow, magenta or (– blue, – green)
Green	Yellow, cyan or (– blue, – red)
Blue	Cyan, magenta or (– red, – green)

* In other words removing all the light from the source.

See Additive colour mixing.

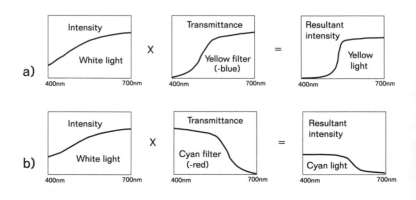

Figure 68 Subtractive filters (a) yellow, (b) cyan

Suicide pin (USA)
An adapter with two male ends.

Sun gun
The term used for any small battery-powered luminaire, originally a small tungsten source, now used to describe any tungsten or discharge source.

Swing (USA)
A crew member who performs the tasks of both grip and electrician, as needed.

System grounding (Neutral) (USA)
The grounding (earthing) of the electrical system by the neutral wire to the star point of the main power transformer and also to earth.

T

T-bone (USA)
A metal T-shaped base with a junior receptacle, used to place larger luminaires at ground level. In the UK known as 'Turtle'.

T-stop
The aperture setting of a lens after compensation for transmission loss in the numerous optical elements. The f-stop is based upon the diaphragm aperture and focal length and does not account for overall transmission, therefore t-stops indicate the effective f-stop in terms of how much light passes through the lens system.

E.g., if the f-stop of a lens is f2.8 and its transmission is 86 per cent, its t-stop is given by:

$$T = \frac{f}{\sqrt{transmission}} \qquad T = \frac{2.8}{\sqrt{0.86}} = 3.02$$

See F-number.

Taco cart (Equipment trolley) (USA)
A special cart that carries grip equipment, such as C-stands, apple boxes, wedges, mounting hardware, and grip expendables.

Talent
People and animals appearing on camera, usually actors or presenters, <u>not always talented</u>.

Telescope
A grid-mounted device made from retractable sets of tubes that is used to suspend luminaires at varying heights in the studio. Older types of telescopes were driven by portable power tools, modern systems are generally equipped with integral electric motors.

Three-fer (USA)
An adaptor that provides three female connectors from one male connector.

Three-phase
A type of alternating current that has three legs. The alternating voltage cycle of each leg is a third of a cycle apart (120°).
See Harmonic distortion and Wye-connected system.

Three point lighting
Traditional lighting set-up using a key light, fill and back lights.

Figure 69 Three point lighting

Three-riser (USA)
A stand that has three extensions.

Throw
Generally describes the direction of light from a luminaire and also the effective distance between the luminaire and the area being lit. The light arriving at the subject will also be influenced by the angle of incidence (cos θ).

The luminaires used in the examples that follow are all Fresnel lens type in the flood position.

Standing position (height 1.8 metres)

Luminaire	Output candelas	Luminaire ht. (m)	Horiz. dist. (m)	Throw (m)	Angle degrees	Cos. of angle	Lux
1 kW tungsten	10 800	4	3	3.72	36	0.81	629
2 kW tungsten	25 000	4	4	4.57	29	0.88	1051
3 kW tungsten	45 000	5	5	5.94	33	0.84	1075
5 kW tungsten	75 000	5	6	6.80	28	0.88	1431
1.2 kW discharge	70 000	4	5	5.46	24	0.92	2147
2.5 kW discharge	100 000	4	6	6.39	20	0.94	2300
4.0 kW discharge	200 000	5	7	7.70	25	0.91	3070
6.0 kW discharge	300 000	5	8	8.62	22	0.93	3752

Seated position (height 1.3 metres)

Luminaire	Output candelas	Luminaire ht. (m)	Horiz. dist. (m)	Throw (m)	Angle degrees	Cos. of angle	Lux
1 kW tungsten	10 800	4	3	4.04	42	0.74	493
2 kW tungsten	25 000	4	4	4.83	34	0.83	890
3 kW tungsten	45 000	5	5	6.22	36	0.80	935
5 kW tungsten	75 000	5	6	7.05	32	0.85	1285
1.2 kW discharge	70 000	4	5	5.68	28	0.88	1908
2.5 kW discharge	100 000	4	6	6.58	24	0.91	2107
4.0 kW discharge	200 000	5	7	7.92	28	0.88	2820
6.0 kW discharge	300 000	5	8	8.81	25	0.91	3505

Tie-in

The connection of temporary distribution cables to a facility's electrical service panel. This presupposes that there is sufficient power available for the extra lighting units. The connections need to be made by a skilled person as this can be an extremely dangerous operation.

Tilt

Term describing the vertical movement, about a point, of luminaires or equipment. Can also refer to camera mounting heads.

Titan (USA)

A 350 A carbon arc luminaire manufactured by Mole Richardson. Known as Super Brute in UK.

Tower

A temporary platform usually made from scaffolding, on which to mount luminaires.
See Scaffold platforms.

Tracing paper

Thin, translucent paper used to white out windows.

Transformer

1) Voltage: consists of a set of insulated windings on a laminated steel core that is used to transfer energy of a.c. in the primary winding to that of one or more secondary windings by inductive coupling. The primary and secondary coils are insulated form each other. The ratio given for a transformer indicates the transformation figure, e.g. a 10:1 transformer would be used to change 240 V to 24 V.
2) Auto: an auto-transformer is a transformer having part of its winding common to the primary and secondary circuits. Therefore, there is no separation between primary and secondary coils.

3) Current: it is difficult to construct ammeters to carry currents greater than 100 A, so it is normal practice to use a current transformer. An ammeter used with a current transformer will usually be one with a full-scale deflection of 5 A. The number of secondary turns used will provide the correct deflection in relation to the current in the primary. Normally, there will be a small number of turns on the primary side and a larger number on the secondary. When current transformers are fitted to bus bars, the primary is the bus bar itself and the current transformer is a toroid surrounding the bar.

Current transformers are also used to sample high currents for feedback circuits in equipment such as dimmers and electronic control ballasts.

Translucent

A material that, although allowing the passage of light, does not allow a clear image to pass through.

Transmission

Given in percentage, is the amount of light passing through a material, particularly colour filters, scrims and diffusers. Its practical application is to give guidance as to the incident light level and exposure in stops, as an aid to balancing the overall lighting and hence the picture.

Tree

A tall stand or tower that has horizontal pipes on which luminaires can be hung. Used a great deal in theatre and concert lighting.

Tri-stimulus

The spectral difference between sources can be quite considerable, as shown in *Figure 70* where the source consisting of continuous power throughout the visible spectrum is matched by three narrow bands of energy in the red, green and blue only. If three primary sources of light

which are derived from standard white light filtered by a red, a green and a blue filter, these can be used as standard sources for colour mixing. The CIE system is based upon using a standard observer who is seated in front of a white screen. On one half of the screen is projected some arbitrary light source, on the other half of the screen is projected a combination of the three primaries. The observer has to adjust the intensity of the three primaries until both sides of the screen match exactly in colour and brightness. Although the two halves of the screen now look the same, they do not necessarily have the same spectral composition. The amounts of red, blue and green used to match the arbitrary light source can be used to calculate the tri-stimulus value of the colour.

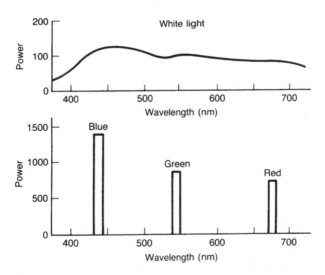

Figure 70 Three colour stimulation

Figure 71 shows the three primaries chosen by the CIE. The green primary curve also shows the sensitivity of the

human eye to light of different wavelengths and, as can be seen, the eyes' sensitivity is at a maximum at around 550 nm but very poor towards the blue and red ends of the spectrum. By using the *photopic curve*, as it is known, as a 'multiplier' for any spectrum which is being analysed, the apparent brightness can be calculated.

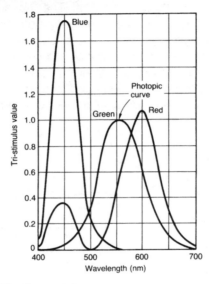

Figure 71 CIE primary colours

The X, Y and Z values are called the tri-stimulus values of the spectrum and the relative amounts of each give the colour and brightness of the viewed scene. The colour co-ordinates are derived from the following formula:

$$x = \frac{X}{X + Y + Z} \qquad y = \frac{Y}{X + Y + Z} \qquad z = \frac{Z}{X + Y + Z}$$

where X is Red
 Y is Blue
 Z is Green

As the sum of x + y + z will always equal 1, only two variables are needed as the third can be determined from the other two. By convention, the co-ordinates x and y are used to describe the colour. It must be noted however, that those co-ordinates only specify the hue and the saturation of the colour, not its brightness. To ascertain the brightness, it is necessary to use the value of Y, the green tri-stimulus value (photopic curve). Moving from the periphery of the colour locus towards the centre of the diagram, saturation of colours diminishes until white is reached. The centre of the colour locus which is positioned at the co-ordinates x = 0.33, y = 0.33, where the saturation has become zero. This point is known as *equal energy white* or reference white (colour temperature 9600 K).

The CIE method allows:

1) analysis of the colour of a surface.
2) analysis of the spectrum of a light source arriving at a surface.

The CIE adopted three standard light sources and these are:

Source A: This is a source typical of an incandescent lamp operated at a colour temperature of 2856 K.

Source B: This source is typical of noon sunlight and has a colour temperature of about 4870 K.

Source C: This represents an overcast sky or average daylight and has a colour temperature of about 6700 K.

Modern colour light meters, such as those manufactured by Minolta, measure the three primaries and internally calculate their x and y values, Y (brightness) and colour temperature when the source is on or near the blackbody. By reference to the CIE diagram it is possible to pinpoint colours with absolute accuracy.

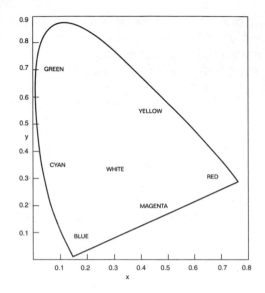

Figure 72 CIE diagram

Tripe
The groups of flexible cables from a theatre lighting bar to the permanent power outlets around the periphery of the stage area.

Trombone (USA)
Term for an adjustable Drop arm.
See also Drop arm.

Truss
A framework, generally made from alloy bars together with cross bracing, to provide lightweight rigging structures. Trusses are used predominantly in TV temporary lighting rigs and concert lighting to support luminaires and other equipment at high level. The size of the truss dictates the amount of weight to be supported without dangerous deflection.

Tungsten halogen

Describes a family of lamps with either hard glass or quartz envelopes, *tungsten* filaments and *halogen* (usually iodine or bromine) fillings.

Tungsten halogen lamp

A lamp designed to maintain an almost constant colour temperature and a high lumen output throughout its life. The halogen cycle is a regenerative process that prevents the blackening of the inside of the bulb.
See Halogen cycle.

Turtle stand

A very low stand to position luminaires at ground level.

Tweenie (USA)

A 650 W Fresnel luminaire manufactured by Mole Richardson Co.

Twist-lock

A connector for which the plug inserts into the socket and then twists, locking the plug to the socket.

Two K

A colloquial term for a 2 kW spotlight.

Twelve-by (USA)

12 ft square butterfly, made from silk or net.

U

Ultraviolet (UV)
The band of short-wave radiation from 400 nm to 10 nm, although invisible to the eye the energy is extremely powerful and produces reddening of the skin (sunburn). UV-A is black light. UV-B radiation can cause skin burns and eye damage as well as skin cancer if not filtered.

Ultraviolet radiation covers the range 4–400 nm and it begins at the short wavelength limit of visibility (violet) and extends to x-rays. It is divided into near (400–300 nm), far (300–200 nm) and extreme (below 200 nm). The near ultraviolet energy is known generally as blacklight. The UV emitted is used to excite fluorescent pigments used in dyes, paints and materials to produce effects for advertising and, more importantly to us, in the theatre and sometimes on television. The ultraviolet radiation in sunlight on the surface of the earth extends from about 300 nm to 390 nm and is generally our means of getting a suntan, with very long exposures causing cancer of the skin. At wavelengths shorter than this, UV becomes exceedingly dangerous to the human being. The reasons for this are that the radiation between 300 and 390 nm is little absorbed and is not so active on organisms, whereas the radiation between 200 and 300 nm is well absorbed, produces damage to cells and the effect is nearly always permanent.

Underwriters Laboratory (UL) (USA)
An American independent test laboratory that ensures minimum safety standards of equipment.

Undo
A memory system feature for cancelling the last instruction and returning the console to its previous set-up.

Unilux (USA)
A manufacturer of strobe lighting equipment that can be synchronized to a motion picture camera shutter.

Up-fade
The portion of a fade that involves only channels that are increasing in level.

V

Variac
An auto-transformer dimmer.

VEAM connector
VEAM Litton is a manufacturer of connectors, including multi-pin discharge source head feeder connectors and single conductor feeder cable connectors.

Velum
See Tracing paper.

Visible spectrum
The narrow band of electromagnetic radiation which lies between ultraviolet and infrared with wavelengths from 0.0004 mm (400 nm) to 0.0007 mm (700 nm), is detectable by the human eye and is known as light.

400 nm	450 nm	475 nm	500 nm	575 nm	650 nm	700 nm
VIOLET	BLUE	CYAN	GREEN	YELLOW	ORANGE	RED

Figure 73 Visible spectrum

Visqueen (USA)
Plastic material used to protect equipment from rain and snow.

Volt (V)
A unit of electrical force. One volt is required to pass one ampere of electricity though a resistance of one ohm.

Voltage drop
That loss of volts which occurs through energy wastage when a current passes through a cable or electronic device. The maximum allowed voltage drop for the UK is 4 per cent of the nominal voltage, which is 9.6 V with a 240 V supply.

Volt drops through typical cables used for distribution systems are given below.

Current rating	Conductor size	Conductor type	Volt drop*	Cable type
16 A	2.5 mm^2	Copper	19	Twin cable
45 A	6.0 mm^2	Copper	7.7	Twin cable
125 A	25 mm^2	Copper	1.7	Three core cable
400 A	185 mm^2	Copper	0.27	Single (short runs)
400 A	240 mm^2	Aluminium	0.45	Single (long runs)

* Voltage drop is given as **mV/A/m** for the **length of route** and represents the voltage drop in the outgoing and return conductors, at normal operating temperatures.

Note: all insulation is 85°C rubber and is heat, oil resistant and flame retardant. Code HOFR. The voltage rating is 450/750 V.

Volt-ampere (VA)

Voltage times current. In d.c., volts × amps = watts. In a.c. circuits, inductance and capacitance will introduce reactance, causing a discrepancy between the watts and volt-amperes.
See Power factor.

Voltmeter

A meter used to measure voltage difference between two points in a circuit.

W

Wall sled (USA)
A luminaire-mounting device that hangs from the top of the set wall and rests against the wall.

Wall spreader
Hardware that mounts to either end of a piece of timber, creating a span from one wall to another from which luminaires can be hung.

Wash
General ambient light on the acting area.

Watt (W)
A unit of electrical power, the product of voltage and current.

Wattage
The power consumption measured in watts or, more commonly, kilowatts. Is used to rate the power of equipment such as lamps, luminaires and dimmer capacity.

Wedge
A triangular wooden block used to level dolly track.

Welding cable
A flexible electrical cable once widely used for power distribution. Welding cable is now prohibited, except for its use as an earth wire.

Western dolly (USA)
A flat-bed camera platform with large inflated tyres, steerable at one end and useful for moving heavy luminaires and cable.

Wiggy (USA)
A continuity or resistance-testing device.

Winch

Term used to describe either manual or motorized lifting equipment.

Figure 74 Standard winch mounted above TV studio grid

Wind-up stand

See Crank-up stand.

Wire rope

Ropes formed from fine wires woven in complex patterns to give great strength.

Working lights

See House lights.

Wrap

The process of taking down luminaires and coiling cable that begins after the last shot of the day has been completed successfully.

Wye-connected system

A common type of three-phase transformer arrangement, also known as a 'Star' system. Voltage reads 415 V (*208 V*) between any two of the phases and 240 V (*120 V*) between a phase and the neutral.

Figure 75 Star connected system

X

Xenon lamps

These lamps have been used for many years in film projectors and follow spots with great success, owing to d.c. operation which means that the arc does not flicker. As the arc provides a very small source, it can be accurately aligned in an optical system to give high output efficiency, with a colour rendering index approaching 95. An advantage of xenon lamps is that no warm-up time is required before they reach full output, therefore the lamps can be switched on and off without any problems. A wide range of lamps is available from 75 W through to 10 kW. Unfortunately, the lamp produces large quantities of ultraviolet radiation and, when hot, requires a high voltage of around 40 V to strike. The d.c. supply consists of a transformer and rectifier unit to supply the low voltage high current required by the lamp.

There is a safety problem with xenon lamps because of the high internal pressures which can be from 6 to 8 atmospheres when cold and 15 to 20 atmospheres when hot. Special precautions must be taken to prevent access to the housing for a considerable period after switch off to allow the internal pressure to drop and, even when cold, the manufacturers recommend that protective gloves and goggles are worn when handling the xenon lamp and special precautions are taken when transporting it.

Xenon luminaire

An extremely bright type of arc discharge luminaire that has a colour temperature of 5600 K. Because the arc is very small, the light can be channelled into a very narrow shaft of extremely bright light.

Y

Y-1
A type of gel that converts a white carbon arc to normal daylight colour balance, by reducing the UV output.

Y-connected system
See Wye-connected system.

Yoke
The suspension frame of a luminaire; possibly containing the drive mechanism for pan and tilt (also fork, stirrup, trunnion, bail).

Z

Zip cord (USA)
Two-wire, 18 AWG electric lamp cord.

Zip light (USA)
A small flood luminaire often used in confined areas to bounce light off ceilings.

Zone system
Ansel Adams' system of eleven gradations of grey from pure black to pure white. The zones are numbered in Roman numerals from 0 to X. There is a one-stop difference from zone to zone.

Zoom
1) The movement of a series of elements within a lens to change the focal length of the lens, allowing wide to fairly narrow coverage. To maintain a good aperture the front elements are often fairly large and therefore zoom lenses are quite heavy.
2) Used in profile spots, follow spots and scenic projectors, consisting of the relative movement of two simple lens elements to change beam width and focus. A simple zoom relies upon the two lenses being adjusted independently for beam size and focus, thus requiring two controls. More complex designs use only one control to change the size of the beam whilst retaining image focus.

Appendix 1
LUMINAIRE SAFETY

Mechanical

The luminaire should be designed in such a way that in the event of a lamp exploding, fragments of glass or quartz 3 mm in size should not escape directly in line, from a lamp, through a ventilator or other aperture. If the ventilation system is designed with a labyrinth or fitted with a mesh, to prevent pieces of glass or quartz 3 mm in size coming out from a directly exploding lamp, in such a way that the glass is caught within the labyrinth or by the mesh, this is accepted within European standards.

Open faced luminaires require either a safety glass with a minimum thickness of 3 mm or a safety mesh that will not permit pieces of glass or quartz 3 mm in size to pass through it. Luminaires that have a single lens, such as a Fresnel, require a safety mesh in front of the lens of such a size as to prevent pieces of glass 25 mm to pass through it. However, luminaires with more than one lens do not require a mesh, but it is good practice to fit one. Luminaires that have a safety glass require a safety mesh in front of it, to prevent pieces of glass 12 mm passing through it. The glass and mesh must be captive in the luminaire. In the event of a safety glass or lens cracking, its mounting must retain the broken pieces in position.

The mechanical connection between the yoke and the luminaire must be locked against loosening. This is to prevent the pivots working loose, during operational use, by tilting the housing. Forms of locking may consist of either fitting a locknut or drilling and pinning the pivot shaft.

The mechanical safety of the yoke requires a 10:1 safety factor on each leg of the yoke so that if one side of the yoke is disconnected from the housing the remaining leg provides a 10:1 safety factor.

The size and type of spigot to be used can be determined from the following:

Luminaires weighing up to 7.5 kg may use a 16 mm diameter spigot and it can be made of either steel or aluminium. Over 7.5 kg a 28.6 mm spigot is required and it must be manufactured from steel (aluminium is not permitted).

A dedicated anchor point must be provided on the housing (unless it is intended for floor mounting or is to be used as a hand-held luminaire) whereby the safety bond can be passed over the primary means of suspension, through the yoke and terminated at the anchor point. In this way the housing will be arrested even if the yoke breaks.

The top latch which is normally provided for retaining the colour frame and barndoors must be self-closing so that it does not rely on an operator to close it. In this way, an operator is obliged to hold the retaining clip out of the way whilst they withdraw the barndoor or colour frame. On letting go of the catch, it returns to its locked position.

Electrical

Observe the following colour code (Europe)

Brown wire	– live
Blue wire	– neutral
Green/yellow wire	– earth

PVC or other plastic cables should not be used on luminaires. This is because the cable will deform with the heat if it touches the side of the housing. The mains input cable must have a sleeve of insulation where it is clamped at the cable entry.

Any cable passing through a hole in sheet metal must be protected by a secondary sleeve to avoid mechanical damage to its insulation.

All electrical components such as switches, cables,

terminal blocks, lampholders, etc., must be manufactured to the appropriate standards for the individual items concerned.

The termination point of the incoming earth should be in view when the mains input terminals are exposed to enable an inspector to see that the earth is connected. The international earth symbol must be used adjacent to the incoming earth terminal. This must be punched into the metal or stuck onto it so that it cannot be removed. The earth symbol must be a minimum of 5 mm high. Earthing washers are to be used to cut through the paint and ensure a good earth. The earthing screw is to be a minimum of 4 mm diameter with a machine-cut thread; self-tapping screws are not acceptable. The screw size will increase with electrical current requirements but cannot be reduced for mechanical strength reasons. The screw must be plated steel or manufactured from brass or copper.

All metal parts that can be touched on the outside of the luminaire, that could come into contact with a live part under a single fault condition, must be earthed. The lamp carriage must have a direct earth continuity wire, a scraping earth conducted along tracks is usually insufficient. Under no circumstances can push-on terminals be used for earth connections to luminaires that draw more than 3 A from the mains supply.

The yoke must have earth continuity to the housing if there is a risk of a single electrical fault. Since there is normally no wiring in the yoke there is no necessity for a separate earth bond on the yoke. **In the case of motorized lights there will generally be wiring in the yoke.**

Luminaire operation and safety

- When connecting the luminaire to the mains supply, ensure that it is effectively earthed, that the mains supply is at the rated voltage and that the correct polarity is observed.

- Lamp replacement must only be carried out after the luminaire has been disconnected from the electricity supply. Allow sufficient time for the lamp to cool before removing it from the equipment. (Cooling could take as long as five minutes.)
- Only use lamps of the recommended type and observe the maximum wattage limitation marked on the luminaire. Observe the lamp manufacturer's recommendations relating to lamp type.
- Insertion of the lamp into the lampholder by holding the envelope may cause mechanical breakage of the lamp and/or seal. For safety, install by holding the lamp with gloves or protective sleeve and use eye protection where appropriate.
- Do not handle the quartz envelope with bare hands. Oil or grease from the skin may contaminate the surface of the envelope and in operation reduce performance and cause premature failure. If the quartz is accidentally handled, clean it before operation with a cloth moistened with alcohol or methylated spirit.
- In certain circumstances, items made from quartz or glass may shatter. Prevent water droplets splashing onto a hot lamp as they may cause the envelope to break.
- A suitable safety mesh or glass must be fitted to protect persons and property in the event of a lamp shattering – this is most important when lamps are used in open fronted luminaires. If the safety glass or lens should become damaged with deep scratches or chipped edges, they must be replaced.
- The lamp shall be changed if it has become damaged or thermally deformed.
- At the end of life, lamps should be broken in a suitable robust container or wrapped to retain quartz fragments. The gas filling has a slight toxic content and large quantities of lamps should only be broken in a well ventilated area.

- Direct exposure to discharge and high intensity tungsten halogen lamps can cause ultraviolet irritation to the skin and eyes. The use of glass or other UV filters is advised if the lamp is used in close proximity or for a prolonged period. When reflector fittings are used to concentrate the light in open fronted luminaires, the safe exposure period will be reduced. Appropriate screening of people and surroundings must be provided.
- The luminaire must be mounted on a firm support or stand and positioned at a safe distance from any flammable material, e.g. curtains or scenery.
- A high amount of radiant heat is produced and high surface temperatures develop. Avoid operation in close proximity to human skin, as burns could result.
- Avoid improper operation of the lamp, e.g. over-voltage, or at burning angles not designed for the lamp type.
- Luminaires must not be operated in explosive or flammable atmospheres or other hazardous areas.
- All luminaires that are suspended must be fitted with a secondary independent means of support, i.e. a chain or bond. Removable accessories must be retained to prevent them falling if they become dislodged.
- The top of the unit has been indicated to prevent it being mounted upside down.
- Special care must be taken with portable luminaires and hand-held lamps. When de-mounting the luminaires, allow them to completely cool before standing them on a flammable surface or placing them in a carrying case.
- For replacement parts, refer to the manufacturer's parts list for the recommended type of safety glass, wire guard, safety suspension bond and any relevant accessories.
- Service and repairs must only be carried out by a qualified person.

Additional requirements for discharge luminaires

These require the same standards as the tungsten halogen units, plus the following.

UV protection

Where a luminaire is not fitted with a glass lens a safety glass must be provided to absorb the UV radiation from the lamp. The glass should have a minimum thickness of 3 mm to provide adequate mechanical strength. However, with higher wattage luminaires, an increased thickness of glass will be required to give added strength. For UV protection, the safety glass must remain in position and be replaced if it is cracked, broken or has deep scratches.

Door opening

The lens door may be screwed closed, in which case it would not require a safety switch. In the event that the door can be opened without a tool, then a double pole mains isolation switch can be used (good practice but not a standard) which must be activated by the glass of the lens so that the unit will not work if the lens is removed or the door is open. The activator must be designed so that it cannot be operated by hand, i.e. enclosed in a tube with a push rod to prevent the operator holding the switch closed and operating the unit. Some manufacturers use a trip relay that does not re-activate until it is manually reset. The same safety requirements apply to open fronted discharge luminaires that are fitted with a safety glass.

Appendix 2
MECHANICAL REGULATIONS

See: THE SUPPLY OF MACHINERY (SAFETY) REGULATIONS 1992 (1992 No. 3073), together with AMENDMENT 1994 (1994 No. 2063)

For any person engaged in the entertainment industry who is involved with either motorized luminaires, grid systems or 'pop' rigs, these regulations have to be fully understood as they are not just recommendations but Statutory Instruments where failure to comply could lead to imprisonment and/or a heavy fine. It is obviously impossible in this publication to cover the documents completely but the following is given as a brief guide. It is strongly recommended that the full regulations are obtained and studied in full.

Definition of 'responsible person'
a) *"the manufacturer of the machinery"*
b) *"the manufacturer's authorised representative in the Community"*
c) *"the person who first supplies the relevant machinery in the Community"*

Definition of machinery
a) *An assembly of linked parts or components, at least one of which moves, including, without prejudice to the generality of the foregoing, the appropriate actuators, control and power circuits, joined together for a specific application, in particular for the processing, treatment, moving or packaging of a material;*
b) *an assembly of machines, that is to say, an assembly of*

items of machinery as referred to in a) above which, in order to achieve the same end, are arranged and controlled so that they function as an integral whole notwithstanding that the items of machinery may themselves be relevant machinery and accordingly severally required to comply with these Regulations; or

c) *interchangeable equipment modifying the function of a machine which is supplied for the purpose of being assembled with an item of machinery as referred to in a) above or with a series of different items of machinery or with a tractor by the operator himself save for any such equipment which is a spare part or tool.*

There are exclusions regarding certain types of machinery and the Regulations should be consulted with regard to these.

General requirements
"No person shall supply relevant machinery or safety component unless the requirements of Regulation 12 are complied with.
Where a person –

a) *being* **the manufacturer** *of relevant machinery or relevant safety component, himself put that relevant machinery or safety component into service in the course of a business; or*

b) **having imported** *relevant machinery or safety component from a country or territory outside the Community, himself puts that relevant machinery or safety component into service in the course of a business."*

Requirements for the supply of machinery
a) *The relevant machinery satisfies the relevant essential health and safety requirements;*

b) *"the appropriate conformity assessment procedure in respect of the relevant machinery has been carried out"*
c) the responsible person, at his election, has issued either –
 i) *"an EC declaration of conformity", or*
 ii) *"a declaration of incorporation"*
d) *"the CE mark has been properly affixed by the responsible person"*
e) the relevant machinery is in fact safe.

Machinery manufactured for European standards

The responsible person must

a) *"draw up and forward to an approved body a technical file"*
b) *"submit the technical file for verification that the standards have been correctly applied; and request that a certificate of adequacy is issued"; or*
c) *"submit the technical file together with an example of the relevant machinery for EC type examination".*

The **Technical File** must include the following:

a) *"An overall drawing of the machinery and control circuits".*
b) *"Fully detailed drawings together with calculations, test results and any other data that may be required to check the conformity of the machinery with the health and safety requirements".*
c) *"A description of methods adopted to eliminate hazards presented by the machinery".*
d) *"A copy of the instructions for the machinery".*
e) *"For series manufacture, the internal measures that will be implemented to ensure that all the items of machinery are in conformity with the provisions of the Machinery Directive".*

CE marking

For the purposes of these Regulations, the CE marking shall not be regarded as properly affixed to relevant machinery unless:

a) that machinery –
 i) satisfies the relevant health and safety requirements; and
 ii) is safe; and
b) the responsible person who affixes the CE marking to the relevant machinery –
 i) has carried out the appropriate conformity assessment procedure and issued an EC declaration of conformity in respect thereof;
 ii) affixes the said marking in a distinct, visible, legible and indelible manner; and
 iii) in the case of relevant machinery which is the subject of Community Directives other than the Machinery Directive, which also provide for the affixing of the CE marking, has complied with the requirements of those other Directives in respect of that machinery:
d) No markings which
 i) are likely to deceive any person as regards the meaning and form of the CE marking or:
 ii) reduce the visibility of legibility of the CE marking shall be fixed to relevant machinery.

Modifications

Where the responsible person complies with one of the conformity assessment procedures he must inform the approved body of any modifications, even of a minor nature which he or, where the responsible person is not the manufacturer, the manufacturer has made or plans to make to the relevant machinery to which the technical file relates.

Appendix 3
THE LOW VOLTAGE DIRECTIVE (73/23/EEC)

The definition of **low voltage** is voltage above **extra low** (*50 V a.c. or 120 V ripple free d.c.*) but not exceeding 1000 V a.c. or 1500 V d.c. between conductors **or** 600 V a.c. or 900 V d.c. between conductors and earth. All three-phase systems in Europe conform to Low Voltage limits.

All electrical equipment must be safe. If a company uses, sells, rents, leases, etc. unsafe electrical equipment the company will fall foul of many acts and regulations, e.g. Health and Safety at Work Act 1974, Electricity at Work Regulations 1989, Electrical Equipment (Safety) Regulations 1994, Consumer Protection Act 1987, and probably many others. Failure to comply with the acts and regulations is likely to lead to heavy fines and maybe imprisonment. Some of the acts and regulations are concerned with the use of the equipment and the use of electricity in general, rather than the intrinsic safety of the equipment itself.

Electrical Equipment (Safety) Regulations 1994
The Electrical Equipment (Safety) Regulations 1994 implement into UK law the modified Low Voltage Directive. The Regulations came into force on 9 January 1995 but were not fully enforced until **1 January 1997.**

These Regulations are applicable to **all electrical equipment** (except those listed in Appendix 1) that is designed or adapted for use between 50 and 1000 V a.c. or 75 and 1500 V d.c. and cover domestic electrical equipment and equipment that is intended for use in the workplace.

All suppliers of electrical equipment (whether they are the

manufacturers, authorized representatives, importers, wholesalers, distributors or retailers) have a statutory duty to ensure that they supply only equipment which complies with the requirements of the 1994 Regulations. Any person failing to do so is liable, under summary conviction, to imprisonment, a fine or both.

The principles of the Regulations are:

Only electrical equipment which does not jeopardize the safety of people, domestic pets and property shall be placed on the Community market.

Electrical equipment will be presumed to satisfy the requirements of the Regulations if:

a) it complies with the safety requirements of a European Harmonized Standard; generally speaking this means that the specification reference number will be prefixed by the letters **EN.** Harmonized standards are valid throughout Europe, however they may include National Deviations for particular countries; these deviations are relatively minor but manufacturers intending to sell equipment to particular countries are advised to check for any deviations applicable to that country.

b) in the absence of a relevant harmonized standard, it complies with the safety requirements of a specification published by the International Electrotechnical Commission, the reference number of these specifications is prefixed by the letters **IEC.** Or, in the absence of a relevant harmonized or international standard, it complies with the safety requirements of a published **British Standard.**

(*Note: British Standards usually encompass European Standards, being given EN, IEC and BS numbers.*)

General requirements

To comply with European Requirements suppliers must ensure that their products are designed for use at the designated supply voltage and are of either Class I or Class II construction. It is an offence to supply electrical equipment which relies on protection against electric shock by means of basic insulation alone (Class 0 construction). **It should be noted that some US and Canadian safety specifications only require basic insulation between hazardous and low voltage circuitry and hence equipment tested against this specification is not allowed for use within the UK or Europe.**

There is no mandatory requirement for a manufacturer to have his equipment tested by a third party test laboratory. An authorized member of the company or his authorized representative must make a Declaration of Conformity which, among other requirements, must include the specification to which the equipment complies. However, it would be extremely foolhardy for a company to make a declaration without carrying out stringent testing since, if the safety of the equipment was ever challenged, the company would have no form of defence.

If the company has the facilities to carry out full testing of the equipment to a relevant specification then it may be felt that this would be the best option. However, if there is any doubt about the company's ability to fully test then arranging for testing at a third party test laboratory may be more prudent. Any NAMAS-approved laboratory could be used, however for full peace of mind, one of the laboratories which have been designated as a UK Notified Body may be more appropriate. (A full list of these laboratories is included in the Electrical Equipment Guidance Notes on UK Regulations which is available from the DTI.)

The CE marking requirements
As stated previously it is one of the requirements of the Electrical Equipment (Safety) Regulations 1994 that the equipment is CE marked. The requirements covering the CE mark consist of three parts, all of which must be satisfied, viz.:

- the affixing of the mark on the equipment;
- completing an EC Declaration of Conformity covering that equipment;
- compiling and holding Technical Documentation relating to that equipment.

The CE mark
The CE mark is a visible declaration by the manufacturer that the equipment complies with the requirements of all relevant Directives. The manufacturer must decide which Directives are relevant to his particular equipment. Since we are discussing electrical equipment then the CE mark will cover the Low Voltage Directive, it is also likely to cover the Electromagnetic Compatibility Directive.

The CE mark is intended to indicate to any enforcement authorities that the equipment meets all the relevant Directives and is entitled to access into EEA markets. **The mark is not a European safety mark or quality symbol and should not be presented as such.**

EC Declaration of Conformity
An EC Declaration of Conformity is a written declaration by the manufacturer or his authorized representative that the equipment to which the CE mark has been affixed complies with the requirements of the 1994 Regulations. The declaration must:

- identify the manufacturer or the authorized representative;
- describe the electrical equipment to which it relates;

- specify the standard(s)/specification(s) to which conformity is declared.

A copy of the declaration is not required to accompany every product but must be held within the EEA by the manufacturer or his authorized representative. The declaration must be available for inspection by an enforcement authority if there is reasonable grounds for suspecting that the equipment does not meet the safety requirements. Failure to provide a copy within a reasonable length of time could amount to an offence under the Consumer Protection Act 1987.

Technical Documentation
The Technical Documentation provides the enforcement authorities with the means of assessing the conformity of the equipment to the requirements of the 1994 Regulations. The Documentation must:

- describe the equipment to which it relates;
- contain information about the design, manufacture and operation of the equipment;
- set out the procedures used to ensure the conformity of the equipment with the safety requirements.

It is the manufacturer's responsibility to compile the relevant documentation which must then be kept within the EEA for possible inspection purposes. The documentation must remain available for not less than ten years after the manufacture of the equipment to which it relates has ceased.

Exclusions from the 1994 Regulations
The Regulations **do not** apply to:

- equipment for use in an explosive atmosphere;
- equipment for radiology and medical purposes;
- parts of goods lifts and passenger lifts;
- electricity supply meters;

- plugs and sockets for domestic use;
- fence controllers;
- specialized electrical equipment for the use on ships, aircraft or railways, which complies with the safety provisions drawn up by international bodies in which the Member States participate;
- electrical equipment supplied for export to a country which is not a Member of the European Union or which is not a Contracting Partner to the EEA Agreement.

Appendix 4
ELECTROMAGNETIC COMPATIBILITY DIRECTIVE (89/336/EEC)

The Electromagnetic Compatibility (EMC) Directive, mandatory from 1 January 1996, seeks to ensure that any electrical/electronic equipment throughout Europe adopts certain standards to define the permissible electromagnetic disturbance levels that the equipment is liable to generate. The Directive is extremely important to the lighting industry mainly because of the electronic dimmers used, the control consoles and discharge lighting, all of which are capable of generating some form of electromagnetic interference. It is obviously not practical to quote the entire contents of the Directive, but what follows are some of the implications of the EMC Directive.

For the purposes of this Directive:

1) **'Apparatus'** means all electrical and electronic appliances together with equipment and installations containing electrical and/or electronic components.
2) **'Electromagnetic disturbance'** means any electromagnetic phenomenon which may degrade the performance of a device, unit of equipment or system. Any electromagnetic disturbance may be electromagnetic noise, an unwanted signal or a change in the propagation medium itself.
3) **'Immunity'** means the ability of a device, unit of equipment or system to perform without degradation of quality in the presence of an electromagnetic disturbance.
4) **'Electromagnetic compatibility'** means the ability of a device, unit of equipment or system to function

satisfactorily in its electromagnetic environment without introducing intolerable electromagnetic disturbances to anything in that environment.

This Directive applies to:

apparatus liable to cause electromagnetic disturbance or the performance of which is liable to be affected by such disturbance

which is constructed so that:

a) 'the electromagnetic disturbance it generates does not exceed a level allowing radio and telecommunications equipment and other apparatus to operate as intended';
b) 'the apparatus has an adequate level of intrinsic immunity of electromagnetic disturbance to enable it to operate as intended'.

Declaration of Conformity

In the case of apparatus for which the manufacturer has applied the standards, the conformity of apparatus with this Directive shall be certified by an EC Declaration of Conformity, issued by the manufacturer or his authorized representative, established within the Community.

The Declaration of Conformity must contain the following:

a) description of the apparatus to which it refers
b) reference to the specification under which conformity is declared and, where appropriate, to the national measures implemented to ensure the conformity of the apparatus with the provisions of the Directive
c) identification of the signatory empowered to bind the manufacturer or his authorized representative
d) where appropriate, reference to the EC type-examination issued by a notified body.

The CE conformity mark

The manufacturer or his authorized representative shall also affix the CE mark to the apparatus or else to the packaging, instructions for use or guarantee certificate.

The CE mark consists of the letters 'CE' and the figures of the year when the mark was affixed.

Appendix 5
TUNGSTEN LAMPS

In the tables that follow the light centre length is given in millimetres, life is given in hours and colour temperature in Kelvin.

Single ended tungsten halogen incandescent lamps

	European code (LIF)	USA code (ANSI)	Volts	Colour temp.	Life	LCL	Base
250 W	–	DYG	30	3400	15	36.0	GY 9.5
300 W	CP-81	FKW	120	3200	150	46.5	GY 9.5
	CP-81	FSL	220/230	3200	150	46.5	GY 9.5
	CP-81	FSK	240/250	3200	150	46.5	GY 9.5
500 W	CP-82	FRG	120	3200	150	46.5	GY 9.5
	CP-82	FRH	230	3200	150	46.5	GY 9.5
	CP-82	FRJ	240	3200	150	46.5	GY 9.5
	M-40	–	220/240	2900	2000	46.5	GY 9.5
	–	BTM	120	3200	150	55.5	P28s
	–	EHC	120	3200	300	60.5	G 9.5
	–	EHD	120	2900	2000	60.5	G 9.5
	–	EGN	120	3200	150	63.5	G 22
	–	EGE	120	2900	2000	88.9	P28s
575 W	HX600	FLK	115	3200	300	60.5	G 9.5

600 W	HX601	–	115	3000	1500	60.5	G 9.5
	–	DYS	120	3200	75	36.0	GY 9.5
	–	FMB	120	3050	2000	51.0	GY 9.5
	HX602	–	220/240	3100	300	60.5	GY 9.5
650 W	–	DYR	220/240	3200	50	36.0	GY 9.5
	–	DYS	120	3200	75	36.0	GY 9.5
	–	EKD	120	3400	25	36.0	GY 9.5
	CP-89	FRK	120	3200	200	46.5	GY 9.5
	CP-89	FRL	220	3200	150	46.5	GY 9.5
	CP-89	FRM	240	3200	150	46.5	GY 9.5
	CP-23/CP-67	–	120	3200	100	55.0	GX 9.5
	CP-23/CP-67	FVD	220/240	3200	100	55.0	GX 9.5
	CP-51/CP-69	FKL	120	3200	100	55.5	P28s
	CP-51/CP-69	FKM	220/240	3200	100	55.5	P28s
	CP-49	–	220/240	3200	50	55.5	P28s
	–	FKR	220/240	3100	300	60.5	G 9.5
	–	FKV	120	3150	300	60.5	G 9.5
	CP-39/CP-68	FKG	120	3200	100	63.5	G22
	CP-39/CP-68	FKH	220/240	3200	100	63.5	G22
	–	DTA	120	3200	300	87.0	P40s

	European code (LIF)	USA code (ANSI)	Volts	Colour temp.	Life	LCL	Base
750 W	–	BTN	120	3000	750	55.5	P28s
	–	BTP	120	3200	200	55.5	P28s
	–	EHF	120	3200	300	60.5	G 9.5
	–	EHG	120	3000	2000	60.5	G 9.5
	–	EGR	120	3200	200	63.5	G22
	–	EGG	120	2900	2000	88.9	P28s
900 W	–	BVA	120	3200	75	44.5	GY 9.5
	–	DZJ	220/240	3200	75	44.5	GY 9.5
1000 W	CP-98	–	220/240	3200	125	46.0	GY 9.5
	CP-24	–	120	3200	200	55.0	GX 9.5
	CP-24	–	220/240	3200	200	55.0	GX 9.5
	CP-70	FVA	220	3200	200	55.0	GX 9.5
	CP-70	FVB	240	3200	200	55.0	GX 9.5
	CP-52	FKN	220/240	3200	200	55.5	P28s
	–	BTR	120	3200	250	55.5	P28s
	CP-77	FEL	120	3200	300	60.5	G 9.5
	CP-77	FEP	220/240	3200	300	60.5	G 9.5
	–	FCV	120	3200	300	60.5	G 9.5
	CP-40/CP-71	FKJ	220/240	3200	200	63.5	G22

Wattage	CP code	Code	Voltage	Colour temp	Hours	Length	Base
	–	EGT	120	3200	250	63.5	G22
	–	EGJ	120	3200	500	88.9	P28s
	–	EWE	220/240	3200	250	88.9	P28s
	–	BVT	120	3050	500	100.0	P40s
	–	BVV	120	3200	250	100.0	P40s
	–	CYV	120	3200	250	127.0	G 38
	CP-106	–	220/240	3200	400	127.0	G38
	–	DSE	120	3200	500	N/A	E40s
1200 W	CP-93	–	120	3200	200	63.5	G22
	CP-93	–	220/240	3200	200	63.5	G22
	CP-90	–	120	3200	200	67.0	GX 9.5
	CP-90	–	220/240	3200	200	67.0	GX 9.5
1500 W	–	DTA	120	3200	300	87.0	P40s
	–	CWZ	120	3200	300	100.0	P40s
	–	CXZ	120	3200	300	127.0	G 38
	–	DSF	120	3200	750	241.0	E40s
1900 W (2 filaments: 1250 W + 650 W)	CP-105	–	220/240	3050	250	143.0	GX38q
2000 W	CP-43/CP-72	–	120	3200	400	70.0	GY 16
	CP-43/CP-72	FTM	220	3200	400	70.0	GY 16

	European code (LIF)	USA code (ANSI)	Volts	Colour temp.	Life	LCL	Base
2000 W (Cont.)	CP-43/CP-72	FTL	240	3200	400	70.0	GY 16
	CP-79	–	220/240	3200	350	70.0	GY 16
	CP-75	–	220/240	3200	400	75.0	G 22
	CP-53/CP-74	–	120	3200	400	87.0	P40s
	CP-53/CP-74	–	220/240	3200	400	87.0	P40s
	CP-28	–	220/240	3200	300	87.0	P40s
	CP-92	–	120	3200	400	90.0	G 22
	CP-92	–	220/240	3200	400	90.0	G 22
	–	BVW	120	3200	400	100.0	P40s
	CP-41/CP-73	FKK	220/240	3200	400	127.0	G 38
	–	CYX	120	3200	400	127.0	G 38
	CP-34	–	220/240	3200	300	127.0	G 38
	–	BWA	120	3200	500	127.0	G 38
	–	FWG	120	3200	500	128.0	E40s
	CP-59/CP-76	–	220/240	3200	300	133.0	E40s
	–	BWF	120	3200	400	133.0	E40s
	–	FWH	120	3200	500	171.0	E40s
2500 W	CP-91	–	120	3200	400	90.0	G22
	CP-91	–	220/240	3200	400	90.0	G22
	CP-94	–	220/240	3200	400	127.0	G 38

2500 W (2 filaments, each 1250 W)							
	CP-30	–	220/240	3200	300	143.0	GX 38q
3000 W	HX-48	–	120	3200	400	127.0	G38
	HX-48	–	220/240	3200	400	127.0	G38
3500 W	CP-107	–	220/240	3200	400	165.0	G38
3750 W (2 filaments: 2500 W + 1250 W)							
	CP-58	–	220/240	3200	300	143.0	GX 38q
5000 W (2 filaments, each 2500 W)							
	CP-32	–	220/240	3200	300	143.0	GX 38q
5000 W	CP-29/CP-85	–	220/240	3200	500	165.0	G 38
	CP-29/CP-85	DPY	120	3200	500	165.0	G 38
	CP-46	–	220/240	3200	400	165.0	G 38
	CP-46	ECN	120	3200	400	165.0	G 38
10 000 W	CP-80	–	220/240	3200	400	254.0	G 38
	CP-80	EBA	120	3200	400	254.0	G 38
	CP-83	–	220/240	3200	500	254.0	G 38
	CP-83	DTY	120	3200	500	254.0	G 38
20 000 W	CP-27	–	220/240	3200	500	420.0	G 38
	CP-99	BCM	220/240	3200	350	354.0	G 38

'Pinch protected' tungsten halogen lamps

The pinch temperatures of standard tungsten halogen lamps has to be kept below 400°C to prevent premature failure of the pinch. 'Pinch protected' lamps can be used in compact luminaires where their pinch temperature is allowed to go to 500°C.

Wattage	Ref. no	Volts	Col. temp.	Life	LCL	Base
75	VL75BP	30	3200	75	36.5	GZ 9.5
150	VL175BP	30	3200	75	36.5	GZ 9.5
250	VL250	30	3200	75	36.5	GZ 9.5
400	VL400BP	120/230/240	3200	75	36.5	GZ 9.5
800	VL800BP	120/230/240	3200	75	36.5	GZ 9.5
1000	6995 IBP	120/230/240	3200	250	46.5	GY 9.5
2000	6994 MBP	120/230/240	3200	500	63.5	G 22
2500	86863 HBP	120/230/240	3200	500	179.0	Fa 4
5000	6963 MBP	120/230/240	3200	525	127.0	G 22
5000	6963 NBP	120/230/240	3200	525	127.0	G 38

Double ended tungsten halogen linear lamps

	European code (LIF)	USA code (ANSI)	Volts	Colour temp.	Life	Length	End caps
250 W	P1/8	–	30	3400	12	78.0	R7s
300 W	–	EHM	120	2950	2000	78.0	R7s
400 W	–	EHR	120	2900	2000	78.0	R7s

420 W	–	FFM	120	3200	100	78.0	R7s
500 W	P2/30	FDF	120	3200	400	118.0	R7s
	K1	–	220/240	2900	2000	118.0	R7s
	–	FCL	120	3000	2000	118.0	R7s
625 W	P2/10	–	220/240	3200	200	189.0	R7s
	P2/10	–	120	3200	200	189.0	R7s
	P2/15	–	220/240	3400	75	189.0	R7s
650 W	P2/6	FAD	120	3200	100	78.0	R7s
	–	DWY	120	3400	25	78.0	R7s
750 W	–	EJG	120	3200	400	78.0	R7s
800 W	P2/13	DXX	220/240	3200	75	78.0	R7s
	P2/11	EME	220/240	3200	150	118.0	R7s
1000 W	–	DXW	120	3200	150	93.0	R7s
	P2/35	–	220/240	3200	150	93.0	R7s
	P2/28	FCM	120	3200	300	118.0	R7s
	P2/28	–	220/240	3200	300	118.0	R7s
	P2/29	FHM	120	3200	300	118.0	R7s
	P2/20	–	220/240	3200	300	118.0	R7s
	–	FFT	120	3200	500	167.0	R7s
	P2/7	EKM	220/240	3200	200	189.0	R7s

	European code (LIF)	USA code (ANSI)	Volts	Colour temp.	Life	Length	End caps
1250 W	P2/12	–	220/240	3200	200	189.0	R7s
1500 W	–	FDB	120	3200	400	167.0	R7s
2000 W	P2/27	FEX	220/240	3200	300	143.0	R7s
		FEY	120	3200	300	143.0	R7s

Par sealed beam tungsten halogen lamps

Wattage	LIF	ANSI	Volts	Col. temp.	Life	Beam angle (degrees)	Base
PAR 36							
650	–	FCX	120	3200	100	40X30	Ferrule cap
650	–	DWE	120	3200	100	40X30	Screw terminal
650	–	FBO	120	3400	30	25X15	Screw terminal
650	–	FBE	120	5000	35	25X15	Screw terminal
PAR 64							
500	CP-86	–	220/240	3200	300	10X7	GX16d
500	CP-87	–	220/240	3200	300	11X9	GX16d
500	CP-88	–	220/240	3200	300	21X10	GX16d
1000	–	FFN	120	3200	800	10X7	GX16d
1000	CP-60	EXC	220/240	3200	300	12X6	GX16d

1000	–	FFP	120	3200	800	13X10	GX16d
1000	CP-61	EXD	220/240	3200	300	13X10	GX16d
1000	–	FFR	120	3200	800	25X14	GX16d
1000	CP-62	EXE	220/240	3200	300	25X14	GX16d
1000	–	FFS	120	3200	800	70X70	GX16d
1000	CP-95	EXG	220/240	3200	300	70X70	GX16d

Appendix 6
DISCHARGE LAMPS

Double ended discharge lamps

Watts	Code	Lamp volts	CCT	Life	Max. length	End caps
HMI (OSRAM) *Hot Restrike*						
200	HMI 200 W	80	6000	300	75	X515
575	HMI 575 W/GS	95	6000	750	135	SFc10
1200	HMI 1200 W/GS	100	6000	750	220	SFc15.5
2500	HMI 2500 W/GS	115	6000	500	355	SFa21
2500	HMI 2500 W/S	115	6000	500	210	SFa21
4000	HMI 4000 W	200	6000	500	405	SFa21
6000	HMI 6000 W	123	6000	500	450	S25.5
12 000	HMI 12 000 W	224	6000	500	470	S25.5
12 000	HMI 12 000 W/GS	160	6000	500	470	S30
18 000	HMI 18 000 W	225	6000	250	500	S30
HTI (OSRAM) *Hot Restrike*						
270	HTI 250 W/D	45	4600	250	93	MO-PIN-1mm
300	HTI 300 W/DE	100	6500	600	92	SFc10.4
400	HTI 400 W/D	55	4600	250	100	MO-PIN-1mm
600	HTI 600 W/D	95	5300	250	100	MO-PIN-1mm
MSI (PHILIPS) *Hot Restrike*						
200	MSI 200W	80	5600	300	75	X515

575	MSI 575W	95	5600	750	145	SFc10.4
1200	MSI 1200W	100	5600	750	220	SFc15.5.6
2500	MSI 2500W	115	5600	500	355	SFa21.12
4000	MSI 4000W	200	6000	500	405	SFa21.12
6000	MSI 6000W	123	6000	350	450	S25 5x60
12 000	MSI 12 000W	225	6000	250	470	S25 5x60

Single ended discharge lamps

Watts	Code	Lamp volts	CCT	Life	LCL	Base
HMI (OSRAM) *Hot Restrike*						
125	HMI 123W	80	6000	150	26.7	Special
200	HMI 200W/SE	70	6000	200	39.0	GZY 9.5
270	HMI 250W/SE	50	6000	250	35.0	FaX 1.5
400	HMI 400W/SE	67	6000	650	60.0	GZZ 9.5
575	HMI 575 W/SE	95	6000	750	70.0	G22
1200	HMI 1200 W/SE	100	6000	750	107.0	G38
2500	HMI 2500 W/SE	115	6000	500	127.0	G3
4000	HMI 4000 W/SE	200	6000	500	142.0	G38
HTI (OSRAM)						
150	HTI 150W	90	6500	750	30	GY 9.5

Watts	Code	Lamp volts	CCT	Life	LCL	Base
HTI (OSRAM) *Hot Restrike*						
270	HTI 250 W/SE	45	4600	250	35	FaX 1.5
400	HTI 400 W/SE	55	4800	250	35	FaX 1.5
600	HTI 600 W/SE	95	5300	300	35	FaX 1.5
1200	HTI 1200 W/S	100	6000	600	59	GY 22
2500	HTI 2500 W/S	115	6000	600	85	G 22
HSR (OSRAM)						
400	HSR 400W	67	5600	650	62	GX 9.5
700	HSR 700W	72	6000	1000	75	G22
MSR (PHILIPS)						
200	MSR 200	70	5600	200	39	GY 9.5
400	MSR 400	70	5600	650	62	GX 9.5
575	MSR 575	95	5600	750	125	GX 9.5
700	MSR 700	72	5600	1000	75	G22 X42
1200	MSR 1200	100	5600	800	85	G22/30X53
MSR/SA (PHILIPS) *Hot Restrike*						
220	MSR 200 SA	34	5400	500	36.5	GY 9.5
400	MSR 400 SA	54	5400	400	36.5	GY 9.5

MSR/HR (PHILIPS) *Hot Restrike*

125	MSR 125 HR	80	5600	200	39	GZX 9.5
200	MSR 200 HR	70	5600	200	39	GZX 9.5
400	MSR 400 HR	70	5600	650	60	GZZ 9.5
575	MSR 575 HR	95	5600	750	70	G22
1200	MSR 1200 HR	100	5600	800	107	G38
2500	MSR 2500 HR	115	5600	500	127	G38
4000	MSR 4000 HR	200	5600	500	142	G38

SN (PHILIPS)

220	SN 250	75	5600	2000	55	GY 9.5
440	SN 500	75	5600	2000	70	GX 9.5
660	SN 660	65	5600	500	80	GY 16
880	SN 1000	75	5600	750	95	GY 16

MSD (PHILIPS)

200	MSD 200	68	5600	750	55	GY 9.5
700	MSD 700	72	5900	2000	85	G22

CSR (GE)

400	CSR 400/CS	67	5600	650	62	GX 9.5
700	CSR 700/CS	72	5600	1000	75	G22
1200	CSR 1200/CS	100	5600	750	85	G22

Watts	Code	Lamp volts	CCT	Life	LCL	Base
CSR (GE) *Hot Restrike*						
575	CSR 575/HR	95	6000	750	70	G22
1200	CSR 1200/HR	100	6000	750	107	G38
2500	CSR 2500/HR	115	6000	500	127	G38
4000	CSR 4000/HR	200	6000	500	142	G38
CSI (GE)						
400	CSI.990201	100	4000	500	25.5	Special Pin
1000	CSI.990221	77	4000	500	63.5	G22
CID (GE) *Hot Restrike*						
200	CID.990211	70	5500	150	36.5	Special Pin
300	CID.990413	100	5500	350	36.5	Special Pin
575	CID.990415	95	5500	500	52.0	G22
1000	CID.990222	77	5500	500	63.5	G22
2500	CID.990431	100	5500	350	127.0	G38

Par sealed beam discharge lamps

Watts	Code	Lamp volts	CCT	Life	LCL	Base
HMI (OSRAM) *Hot Restrike*						
1200	HMI 1200 W PAR	100	6000	1000	64	G38
CSI (GE)						
1000	CSI 991222	77	3800	3500	64	G38
CSI (GE) *Hot Restrike*						
1000	CSI 991422/HR	77	3800	3500	64	G38
CID (GE)						
1000	CID.991225	77	5500	1500	64	G38
CID (GE) *Hot Restrike*						
1000	CID.991425/HR	77	5500	1000	64	G38
1200	CID.991435/HR	100	5500	1000	64	G38

Appendix 7
LUMINAIRE PERFORMANCES

Discharge sources

Distance (m)	Spot intensity (lux)	Beam size (m)	Flood intensity (lux)	Beam size (m)
200 W Fresnel				
4	5156	1.27	859	4.16
6	2291	1.90	381	6.24
8	1289	2.53	214	8.33
575 W Fresnel				
4	12500	0.70	1250	4.00
6	5555	1.05	556	6.00
8	3125	1.40	313	8.00
10	2000	1.75	200	10.00
1.2 kW Fresnel				
6	10278	1.16	1944	6.11
8	5781	1.54	1094	8.15
10	3700	1.93	700	10.20
12	2570	2.31	486	12.23
14	1888	2.70	357	14.27
16	1445	3.08	273	16.30
2.5 kW Fresnel				
8	17187	1.19	1562	10.00
10	11000	1.49	1000	12.50

12	7638	1.78	694	15.00
14	5612	2.08	510	17.50
16	4297	2.38	390	20.00
18	3395	2.68	309	22.50
20	2750	2.97	250	25.00
4 kW Fresnel				
10	30000	1.57	2000	9.97
14	15306	2.20	1020	14.00
18	9260	2.83	617	18.00
22	6198	3.46	413	21.94
26	4438	4.09	296	25.93
30	3333	4.72	222	29.91
6 kW Fresnel				
14	24439	1.84	1531	12.47
18	14784	2.36	926	16.03
22	9897	2.88	620	19.60
26	7086	3.41	444	23.15
30	5322	3.93	333	26.71
34	4144	4.46	260	30.28
12 kW Fresnel				
18	30864	1.82	1543	18.74
22	20661	2.23	1033	22.90
26	14793	2.63	740	27.07

Distance (m)	Spot intensity (lux)	Beam size (m)	Flood intensity (lux)	Beam size (m)
30	11111	3.04	556	31.23
34	8650	3.44	433	35.40
38	6925	3.85	346	39.56
42	5669	4.26	283	43.73

18 kW Fresnel

20	24500	2.97	1625	21.27
24	17013	3.57	1128	25.50
28	12500	4.16	829	29.77
32	9570	4.76	635	34.02
36	7561	5.35	501	38.28
40	6125	5.95	406	42.54
44	5061	6.54	336	46.79

Distance (m)	Intensity (lux)			
	Spot	Narrow Flood	Flood	Super wide flood
1.2 kW PAR				
10	25000	7250	2000	1100
15	11111	3222	889	489
20	6250	1812	500	275
25	4000	1160	320	176
30	2777	806	222	122

2.5 kW PAR

10	33750	13700	4500	2000
15	15000	6088	2000	888
20	8438	3425	1125	500
25	5400	2192	720	320
30	3750	1522	500	222

4 kW PAR

10	45000	16200	6000	2500
15	20000	7200	2667	1111
20	11250	4050	1500	625
25	7200	2592	960	400
30	5000	1800	667	278

6 kW PAR

10	71750	35700	12200	6800
15	31889	15867	5422	3022
20	17937	8925	3050	1700
25	11480	5712	1952	1088
30	7972	3967	1356	756

Tungsten sources

800 W Redhead

Distance (m)	Spot intensity (lux)	Beam size (m)	Flood intensity (lux)	Beam size (m)
4	2500	3.07	406	7.46
6	1111	4.60	180	11.19
8	625	6.15	102	14.90

2 kW Blonde

Distance (m)	Spot intensity (lux)	Beam size (m)	Flood intensity (lux)	Beam size (m)
4	13500	1.63	1575	5.60
6	6000	2.44	700	8.40
8	3375	3.26	394	11.20
10	2160	4.07	252	14.00
12	1500	4.88	175	16.80

1 kW PAR

Distance (m)	Intensity (lux)		
	Narrow spot	Spot	Flood
10	3200	2700	1250
12	2222	1875	868
14	1632	1378	638
16	1250	1055	488

Distance (m)	Spot intensity (lux)	Beam size (m)	Flood intensity (lux)	Beam size (m)
1 kW Fresnel				
4	4609	0.77	675	4.8
6	2048	1.16	300	7.2
8	1152	1.54	169	9.61
2 kW Fresnel				
4	11562	0.70	1462	4.53
6	5139	1.05	650	6.79
8	2891	1.40	366	9.05
5 kW Fresnel				
8	7812	1.75	1172	9.05
10	5000	2.20	750	11.32
12	3472	2.63	521	13.58
14	2551	3.07	383	15.80
10 kW Fresnel				
10	12500	1.75	1700	9.10
12	8680	2.10	1181	10.90
14	6378	2.45	867	12.80
16	4883	2.80	664	14.60

Distance (m)	Intensity (lux) (minus eggcrate)	Intensity (lux) (with eggcrate)
1.25 kW Softlite		
2	2700	2250
3	1200	1000
4	675	562
2.5 kW Softlite		
4	1562	1234
6	694	548
8	391	309
5 kW Softlite		
6	1215	972
8	684	546
10	438	350

Distance (m)	Intensity (lux)	Beam size (m)
650 W Profile projector 25° Fixed		
6	972	2.66
8	547	3.55
10	350	4.43
1 kW Profile projector 30° Fixed		
8	1360	4.29
10	871	5.36
12	605	6.43

Distance (m)	Narrow intensity (lux)	Beam size (m)	Wide intensity (lux)	Beam size (m)
1 kW Profile projector 15°/28°				
6	5638	1.58	1620	2.99
8	3171	2.10	911	3.99
10	2030	2.63	583	4.99
12	1409	3.16	405	5.98
14	1035	3.69	298	6.98
1200 W Profile projector 11°/26°				
6	7083	1.15	3611	2.77
8	3984	1.54	2031	3.70
10	2550	1.92	1300	4.62
12	1771	2.31	903	5.54
14	1301	2.70	663	6.46
2 kW Profile projector 12°/22°				
10	4288	2.10	1856	3.90
12	2978	2.52	1289	4.66
14	2188	2.94	947	5.44
16	1675	3.36	725	6.22
18	1323	3.78	573	7.00
20	1072	4.20	464	7.78
2 kW Tungsten follow spot 9°/15°				
12	3955	1.89	1733	3.16

Distance (m)	Narrow intensity (lux)	Beam size (m)	Wide intensity (lux)	Beam size (m)
14	2906	2.20	1273	3.68
16	2225	2.52	975	4.21
18	1758	2.83	770	4.74
20	1424	3.15	624	5.27

1 kW Discharge follow spot 9°/15°

Distance (m)	Narrow intensity (lux)	Beam size (m)	Wide intensity (lux)	Beam size (m)
20	4284	3.00	2556	5.34
22	3540	3.31	2112	5.87
24	2975	3.61	1775	6.40
26	2535	3.91	1512	6.94
28	2186	4.21	1304	7.47
30	1904	4.51	1136	8.00

2.5 kW Discharge long throw follow spot 4.3°/7.5°

Distance (m)	Narrow intensity (lux)	Beam size (m)	Wide intensity (lux)	Beam size (m)
20	8250	1.50	3750	2.62
24	5729	1.80	2604	3.15
28	4209	2.10	1913	3.67
32	3222	2.40	1464	4.19
36	2546	2.70	1157	4.72
40	2062	3.00	937	5.24
44	1705	3.30	774	5.77
48	1432	3.60	651	6.29

Appendix 8
FORMULAE AND
CONVERSION TABLES

Most scientific measurements are made using the International System of Units (Systeme International d'Units), or S.I. for short.

The three basic units are the **metre, kilogram** and the **second**. From these are derived the whole range of units which cover the world of physics.

Measurement of length
Basic unit: **metre** (m)
Other units:
centimetre (cm) = one hundredth of a metre (10^{-2}m)
millimetre (mm) = one thousandth of a metre (10^{-3}m)
nanometre (nm) = one thousandth millionth of a metre (10^{-9}m)

Measurement of area
Basic unit: **square metre** (m^2)
Other units:
square centimetre = one ten-thousandth of a square metre ($10^{-4}m^2$)

Measurement of mass
Basic unit: **kilogram** (kg)
Other units:
gram (g) = one thousandth of a kilogram (10^{-3} kg)
tonne (t) = one thousand kilograms (10^3 kg)

Measurement of electric current
Basic unit: **ampere** (A)
Other units:
milliampere = one thousandth of an ampere (10^{-3}A)

Measurement of thermodynamic temperature
Basic unit: **kelvin** (K)

The kelvin scale uses the same interval of degrees as the Celsius scale. 'Absolute zero' on the kelvin scale is **minus** 273 degrees Celsius.
Thus: K = (°C) + 273.

Measurement of light

	Physical units	**Luminous units**
Total light output	Radiant flux (watts)	Luminous flux (lumens)
Light emitted in a specific direction	Radiant intensity (watts per steradian)	Luminous intensity (**candelas**)
Light emitted from a unit area in a specific direction	Radiance (watts/cm^2 per steradian)	Luminance (candelas/cm^2)
Light striking a unit area	Irradiance (watts/cm^2)	Illuminance (lumens/m^2) (**lux**)

Laws of illumination

Inverse square law $$E = \frac{I}{d^2}$$

where E is illuminance in lux, I is luminous intensity in candelas, and d is distance of source to surface being illuminated.

Cosine law $$E = \frac{I}{d^2} \; Cos.\theta$$

where θ is the angle to the normal of the incident light.

This is a modification to the inverse square law to take account of the angle of incidence.

Electrical formulae

Ohms law states that the current (I) flowing in a circuit is directly proportional to the applied voltage (V) and inversely proportional to the resistance (R), thus:

$$I = \frac{V}{R} \qquad V = IR \quad \text{and} \quad R = \frac{V}{I}$$

Power (P) in the circuit is given by the product of voltage (V) and current (I). The unit of power is the watt (W), thus:

$$P = V \times I \text{ watts}$$

alternatively as V = IR: therefore $P = I^2R$ watts

as $I = \frac{V}{R}$: therefore $P = \frac{V^2}{R}$ watts

The above formulae are those used for direct current (d.c.) circuits.

For alternating current (a.c.) circuits, the formulae only hold true when the circuit is purely resistive. That is, the voltage and current are in phase with each other. If the circuit contains inductance or capacitance the voltage and current will be out of phase to some degree and, to allow for this, the formulae is modified as follows:

In an a.c. circuit the ratio of applied voltage (V) divided by current (I) is called the impedance (Z):

$$Z = \frac{V}{I}$$

The power is given by:

 P = VI Cos φ watts

where φ is the phase difference between the current and supply voltage.

Cos φ is called the power factor (P.F.)

The power factor is also given by:

$$\frac{\text{Power in watts}}{\text{r.m.s. volts} \times \text{r.m.s. amperes}}$$

For most practical measurements:

 P.F. $= \dfrac{\text{kilowatts}}{\text{kilovoltamperes}}$

Electrical energy
This is the measurement of power used over a period of time

Thus: Watts × seconds = watt-seconds or 'joules' (J)
 1 kWh = 1000 × 3600 watt-seconds
 = 3 600 000 J

For practical purposes the units most used are:

 kilowatts × hours = kilowatt-hours (kWh)

Generally called a unit of electricity.

Appendix 9
LAMP CONSTRUCTION, BASES and FILAMENTS (Courtesy of GE Lighting)

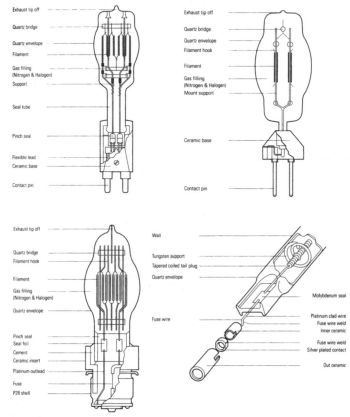

Figure A1 Lamp construction

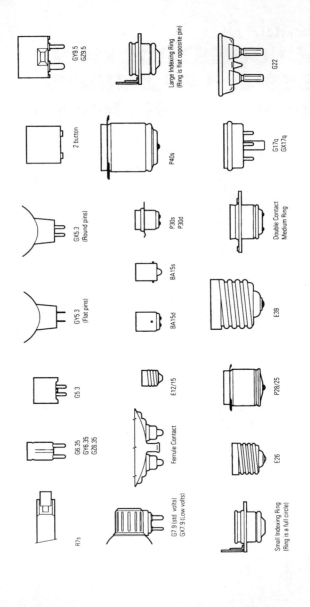

Figure A2 Lamp base types

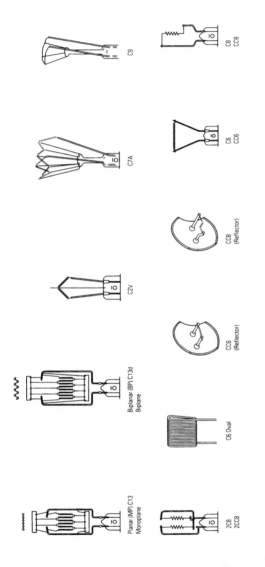

Figure A3 Filament types

FURTHER READING

BS 5550:Location Lighting, British Standards Institution, 1996.

BS 7671:1992 plus amendments (IEE Wiring Regulations, 16th Edition), British Standards Institution, 1994.

Light and Colour, R. Daniel Overheim, David L. Wagner, John Wiley & Sons, 1982.

Light, Michael Freeman, Collins, 1990.

Light, Michael I. Sobell, University of Chicago Press, 1987.

Lighting the Stage, Francis Reid, Focal Press, 1995.

Lighting Technology, Brian Fitt, Joe Thornley, Focal Press, 1998.

Low Voltage Directive (73/23/EEC), European Community Publication, C199, July 1994.

The Gaffers' Handbook, Harry C. Box, Edited Brian Fitt, Focal Press, 1998.

The EMC Directive (89/336/EEC), European Community Publication, L139, May 1989.

The Reproduction of Colour in Photography, Printing and Television, R.W.G Hunt, Fountain Press, 1988.

The Stage Lighting Handbook (Third edition), Francis Reid, A&C Black, 1987.

The Supply of Machinery (Safety) Regulations No. 3073, HMSO, 1992.

The Supply of Machinery (Safety) (Amendment) Regulations No. 2063, HMSO, 1994.

The Technique of Lighting for Television and Film, *3rd Edition*, Gerald Millerson, Focal Press, 1991.

Thorn Technical Handbook (Various), Thorn Lighting.

ACKNOWLEDGEMENTS

BBC
British Standards
Commission Internationale de L'Éclairage
Department of Trade and Industry
DeSisti Lighting
Doughty Engineering Ltd
Fuji Photo Film Co. Ltd
GE Lighting
Health and Safety Executive
Minolta (UK) Ltd
Osram
Philips Lighting
The Institution of Electrical Engineers